MW00710537

WORKING
MOMS

FROM SURVIVAL TO SATISFACTION

MIRIAM NEFF

NAVPRESS

A MINISTRY OF THE NAVIGATORS
P.O.BOX 35001, COLORADO SPRINGS, COLORADO 80935

© 1992 by Miriam Neff
All rights reserved. No part of this publication may be reproduced in any form without written permission from NavPress, P.O. Box 35001, Colorado Springs, CO 80935.
Library of Congress Catalog Card Number: 91-67287
ISBN 08910-96299

Cover illustration: Betsy Everitt

Unless otherwise identified, all Scripture in this publication is from the *Holy Bible: New International Version* (NIV). Copyright © 1973, 1978, 1984, International Bible Society. Used by permission of Zondervan Bible Publishers. Another version used is *The Living Bible* (TLB), © 1971 owned by assignment by the Illinois Regional Bank N.A. (as trustee), used by permission of Tyndale House Publishers, Inc., Wheaton, IL 60189.

Printed in the United States of America

Contents

▼

1 Mom to Mom: Let's Talk 9
2 Guilt: Dealing with the "G" Word 19
3 Understanding "Women's Work" 29
4 Finding Your Fit in the Marketplace 45
5 Pursuing God's Plan for You 59
6 Getting Together: Moms at Home, Moms
 in the Marketplace 73
7 Help for Moms of Young Children 87
8 Choosing the Right Care for Your Kids 103
9 How to Really Love Your Teenager 125
10 Building on Your Investment in the Future 147
11 Handling Change without Creating Crisis 165
Notes 183

To Bob

*For twenty years of shared parenting
and twenty-seven years of unconditional
commitment. I recently asked him how our life
compared to what he had anticipated on our first date,
an outing back in 1963 on a beautiful fall day
in Brown County, Indiana. He answered,
"The challenges and adventure are more than
I ever dreamed." This book is the result of both,
and this working mom could not have written it
without his incredible, ever-believing support.*

Acknowledgments

▼

A special thank-you to my friends who provided their eyes, time, and perspective to critique this manuscript: Janis Backing, Marilyn Cassells, Sandy Dillon, and Phoebe Millis.

Mom to Mom: Let's Talk

Tears rolled down my cheeks and dropped onto my sleeping daughter's face. I cuddled my firstborn baby, five months old, wishing she were awake, wishing the evening were longer. I wanted to coo to her, watch her smile, laugh, drool—anything. But it was seven o'clock in the evening, and she had done those things earlier—with Nana—while I was at work.

My thoughts took me on a familiar little journey.

Does she really know which one of us is her mother?

How will her development be affected by having a working mom?

Do I have enough energy to keep up this pace?

Am I nuts to think I can manage a job as well as a family?

Am I doing something I'm really going to regret years from now?

Is there a better way?

Though I would have liked answers to those questions, what I wanted most at that moment was for my child to stay awake a little longer. I wanted her to hear my songs and murmurings as I stroked the fine strands of hair on her baby-soft head.

▼

Three nights ago and twenty years later, I sat with my daughter in a different state, in a town she now calls home. It was 10:30

p.m., and we were finishing dinner at the hotel restaurant. She had so much more to tell me about her new life of independence, her roommates, her job. I ordered more coffee—for me. I wanted to hear every word, enjoy every moment, listen for her feelings, her fears, her plans, her dreams. Daughter and Mom without a doubt!

FROM ONE MOM TO ANOTHER

In those twenty intervening years, our family grew from three to six. I was a stay-at-home mom for part of that time, dabbling in sales, doing freelance writing, teaching Bible studies, sometimes traveling as a speaker, and volunteering in my children's school. As a mom in the marketplace, I worked as a relocation counselor and also in public education. For most of the twenty years while our family was growing, I reported to a job outside my home, full-time, on a schedule I didn't set.

This experience sent me on a journey of asking others about their experiences, struggling with difficult issues, searching my own soul. Not just because I needed answers for understanding, but also because I needed them for basic survival.

If you're a working mom, you probably know the feeling. Let's talk, mom to mom. Sit down at my kitchen table. I'll brew the coffee—hazelnut, my favorite—and get the half-and-half while you slip off your shoes.

Young mothers, let's talk first—because of all working mothers, I think you experience the greatest physical exhaustion. (Then you can catch a nap while we older moms go at it!)

Though you care about satisfaction issues—what are the right perspectives and why—they probably take a back seat to daily survival issues. You feel eternally *tired*, and you're probably resigned to the idea that fatigue is just going to be your constant companion.

The issues that are staring you in the face revolve around who will care for your children, how much it costs, and whether the location is convenient—or at least workable. You're convinced this has to be the most difficult stage of being a working mother.

Before I start talking, first let me serve you. Let's refill your cup. You do so much caretaking, and you have so few moments, if any, when someone takes care of you.

I have a lot I want to tell you. For now, remember this — *you will survive.* And in the process, you'll learn this precious lesson: *you need to neglect the middle and low priorities, guilt-free.* Choose the few priorities that are really important and forget the rest. Take it from me, a survivor. You can't have it all, so don't even try.

Now a word with older moms. (Younger moms, you're welcome to stay with us while we chat about our experiences — what lies ahead for you. But we understand if you're too tired and need to call it a day.) Pass the coffee and the banana bread. Staying a perfect size eight doesn't seem as important as it used to be — so pass the cream cheese, too.

I'm one of you. Not long ago, all four of my children were adolescents. Now my oldest is twenty and the other three are teenagers. Working was supposed to get easier when the kids reached school age, right? But most of us wonder, *Whatever happened to that sense of relief I was supposed to feel when they were "finally in school"?*

In our children's early years, we decided *who, where, when* — who they were with, where they went, when they ate and slept. Now they've moved out into the Great Wide Open. School throws open many new issues, introduces many new variables. Now they must get along with *many* others — people we haven't chosen, from teachers and playground supervisors to a multitude of peers. And they're expected to learn — at a certain pace, sometimes in a certain way.

It's a good thing they can feed and dress themselves. We need the energy we used to invest in those tasks to coordinate carpools, provide transportation to activities, manage their schedules as well as our own, meet their friends, and develop the process of discovering and developing their unique strengths and interests.

Now it's getting to be a more complex task to sort through the clamor of voices on how to raise children. We've heard all

kinds of advice by now, haven't we? Sometimes it has ener-
gized and encouraged our days. Sometimes it has heaped on
inappropriate guilt and heightened our concerns and fears. One
of the best ways we can help each other is to swap survival
suggestions.

LEARNING FROM OTHER MOMS
That night that I wept over my sleeping infant, I called my
older sister. At the time, she was a working mom, finishing her
master's degree while teaching, parenting children ages two
and four. She gently prepared me for what was ahead.

"Don't be surprised when Valerie reaches out to Nana and
calls her name first. It hurts. But that attachment can be healthy.
And she *will* learn that you're her mom." Coming from some-
one who had been there before me, that helped.

But I heard other voices as well. One lovely fall evening I
was pushing Valerie's buggy around the neighborhood. Since
she was a watcher, not a sleeper, I pushed the buggy with one
arm and balanced her in the other. My neighbor, who was a
caring person, came up to us and cooed into Valerie's beaming
face, "Is that mean old mom still leaving you and going off to
work? How can she leave such a charmer?"

Valerie turned it on—waving her arms, pumping frog legs,
and drooling while she grinned from ear to ear. Fortunately, no
response was needed from me, since I couldn't have answered
anyway. My heart had dropped suddenly with a wordless cry.

Regardless of the age of our children, there will always be
those who don't understand, who cannot help or encourage
us. It's important to seek out women we can call on, who
have understanding born of experience and who will listen
without pronouncing judgment. If they can't always help us
with the answers we need, at least they can walk beside us
when the path seems lonely or difficult. Being a working
mom has brought into my life some incredible friendships
and supportive relationships I never would have discovered
outside the mutual bond of parenting and working.

Other moms are an important source of help and infor-

mation. If your children are in grade school, you've probably discovered the women who are committed to their children's expanded opportunities for learning and development. These moms are fanatically devoted to communication and carpools. They're walking encyclopedias on swim programs, private music teachers, recreational facilities, and orthodontists with flexible hours. These networks may provide a support base for you as your children move into adolescence.

Swap stories with other moms across the kitchen table. A lot of the encouragement I've received has come simply from hearing others' experiences—not from glowing gems of advice others have deposited with me, though learning what works is helpful. I find that listening to others tell their funny, motivational, moving, and unique stories often gives me fresh perspective and a new spirit of energy. I can go on.

The coffee pot runs low as we laugh about our bloopers. My friend Karen worked in an emergency room while her two children were preschoolers. She recalled describing an accident victim to the attending doctor: "Man fall down, go boom," she announced. "Owwie on arm." Her explanation had flowed naturally for her. But when she felt the stares of the doctor and two other attending professionals, she realized she had forgotten to shift vocabularies when she changed hats.

While I sat in the faculty cafeteria enjoying my soup, a realization gradually soaked through my consciousness. I was wiping my spoon across my chin after every bite as if to "reshovel" my lunch. (If your children are grown now, you may have forgotten this necessary reflex for feeding infants.) I looked around sheepishly to see if my coworkers had noticed and were wondering about my competence.

SURVIVAL AND SATISFACTION
Chances are good that I won't get to sit and have coffee with many of you who are reading this book. But I hope we can communicate. I especially want to encourage you.

I'd like to share with you what I've given up as a working mom, and what I've gained as well. I want to tell you what my

children have given up by having a working mother—but also how they've benefited.

In the brief and broken-up moments when you pick up this book, I want you to discover a few helpful gems. I've collected a number of them from some truly neat people. I've mined others from the ground in my own trenches, where they've been tested and found genuine. Let's share laughter and feelings. Laughing at ourselves and sharing feelings with those who understand are rare treats for us working moms.

Because your "spare time" to read is so precious, I'd like to summarize what's in this book for you. Then you can pick up what speaks to your need at the moment.

I've written this book to meet the two major needs of working moms: survival and satisfaction. We could say these are "outside and inside" needs. The outside survival needs usually win the struggle for our day-to-day attention. They suck up our time and make continual demands on our energy. But inside, the deep-down needs don't go away just because they get stuffed deeper down. They cry out for an inner satisfaction: that secure peace that we have sorted through the issues and gained the courage of our convictions to live our unique lifestyle.

As I've spoken with other working moms, I've found that we have a lot in common. We feel guilty. We're tired most of the time. We're continually confronted by new choices without familiar contexts or good information for making decisions. In the words of the Nike commercials, many of us are *just doing it*. This is the daily grind of our outside, survival mode.

To meet your survival needs, I'll be including lots of survival tips. There are some things we can add to our do-list that actually simplify life's daily routine. There are some things we can scratch off our do-list that will help just as much.

Surviving is important—or should I say necessary. This is where we live most of the time, and we have to deal with these practical realities just to keep going.

But in the depths of our beings you and I know that simple survival isn't enough. In the middle of those busiest moments,

or late at night after a hectic day when we're drifting off to sleep trying to block out of our minds all the things we didn't get done, those nagging questions grab on and won't let go—*Am I making a big mistake? What's it all for? Am I really doing the right thing?*

That's why we'll also be looking at internal issues in this book. I can help you sort through them, because I live with them just the way you do. For those of us who are Christians, the need for spiritual satisfaction creates the unique confusion of trying to sort out the many voices that are eager to tell us what we ought to do and why—often "according to the Bible." I want to help you come to a place of satisfaction as a Christian mom who works.

Here are some highlights of what's in this book to help you as a working mom, on the outside as well as on the inside.

The following chapter is about that sneaky, powerful, two-faced emotion called *guilt*. Have you ever tried to stay so busy that it kept you from feeling? Sometimes the strategy works—with loss or grief, even with anger. But I think that every mom who reads this book, whether she works full-time or part-time, at home or miles away, is *never* too busy to feel guilty. False guilt or real guilt, it's always there. Is this issue your main source of stress today? Go straight to chapter two to learn how to deal with the "G" word.

Chapter three takes a whack at relieving false guilt by exploring the whole issue of "women's work." We live with a lot of unexamined assumptions that load guilt onto us we don't need to carry around. A clear perspective on women's work and family roles, especially when it's grounded in under-standing the present in light of the past, can help us seek God's leading in our lives instead of trying to accommodate other people's expectations. Understanding these issues is critical to avoid internalizing the kinds of comments that make sweeping judgments—"How can you let someone else raise your kids?" "She shouldn't have had the baby if she wasn't ready to stay home and take care of him."

Then we'll turn to a nuts-and-bolts chapter on knowing

ourselves. Once we get a grip on the guilt issue and start building a foundation of confidence in being a working mom, we need some help on the question of where we fit in the marketplace. Chapter four will give you encouragement that there *is* a niche "out there" for you.

How to find that niche is the subject of chapter five, which will give you practical guidelines for discovering God's individual plan for you. We'll look at setting goals, working with realities, and taking action—all in the context of recognizing our relationship to the One who alone can give us true satisfaction.

Chapter six is my plea for moms to unify. Moms at home and moms in the marketplace often compete with each other. It can get downright catty sometimes. But we're sisters. Let's unite around our common goal of wanting the best for our children. I'll make some suggestions for how we can do it.

Then, young moms, a chapter for you: How to get through the survival stage without losing your sanity or your marriage. It's possible! Look up chapter seven if your resources are stretched thin over work and the needs of young children. In chapter eight, we'll follow up with suggestions on choosing the care that's best for your kids.

As the age of our children rises, so does our blood pressure. When they hit adolescence, they're wired and we're tired. But they need our love and attention as much—if not more—than ever. In chapter nine we'll look at how to turn challenges into opportunities while parenting kids on the threshold of becoming young adults.

All of us need to know that we make a difference—in our world, and particularly in the lives of our children. What are we contributing to the generation we're raising? How can we make sure we're drawing on the resources around us to help shape the future for our children? What kind of world will it be after we've lived through it? Chapter ten will suggest some courses of action for building on our investment in the future.

Life as a working mother can make us feel like we're jugglers on a treadmill, trying to keep all the balls in the air while

the treadmill forces us to pick up the pace from a walk to a jog to a run. When we drop one ball, we no sooner get it back in the air than another one jumps out of our hands. Keeping up with change seems to be a constant struggle. In the final chapter, we'll explore how to navigate through these inevitable transitions—handling change without creating crises.

To help you get maximum benefit from this book in minimum time, the chapters ahead each close with a special "Mom to Mom" section. Here I'll single out the few things that I most want you to hold onto. As one mom to another, I want to give you encouragement as well as how-to's, because I think you need both. Use these sections to give you a quick pep talk, a practical tip, or a new angle on an old subject—in bite-sized pieces.

SPEAKING OF WORKING MOTHERS
By now you probably know that this is *not* a book on whether to work outside the home. Working mothers are a reality in our society, and trends indicate there are going to be more and more of us in the future—for whatever reasons. My purpose is not to look at the *whether*, but instead the *why, what,* and *how,* of life as a working mother.

Perhaps some of you reading this book are not yourselves working moms, but you live or work closely with us. You might be a pastor, a youth worker or counselor, husband, a stay-at-home mom thinking about entering the marketplace, or even a home-schooling mom. Use this book to help develop a clear and accurate picture of working moms and our unique challenges and opportunities.

I want to close this chapter with some facts about working moms that are so simple they may sound corny. But I'm listing them because I've discovered through my experiences—sometimes painful ones—that working moms are often misunderstood. See if you hear the ring of recognition in this description:

Working moms love their kids just as much as other parents. They're forced to make compromises. That doesn't mean their

children are not tremendously important to them.

Most working moms are not driven by the desire to acquire things. A chunk of working mothers are single parents below the poverty level. Another chunk are married to spouses who are low wage-earners or unemployed. Increasingly, two-parent families must have two income streams just to make it. The stereotype of working for a glamorous wardrobe, exotic vacations, or upscale living just doesn't hold true across the board.

Working moms may live on survival energy one day at a time, but they do care about the larger issues that affect the marketplace and their families. They are not thoughtless career seekers or small-minded workers with tunnel vision. They care about the kind of world we're all creating and the contributions they are uniquely positioned to make.

Do you see yourself, or someone you know, in this description? Let's build on the positives instead of harping on the negatives. Let's take a hard look at the realities and celebrate the possibilities. When our coffee talk around the table draws to a close, let's go back to our lives and our routines with a renewed sense of confidence and competence. Not just for our benefit, but for the benefit of our children and our families. God Himself is at work in our lives.

Guilt: Dealing with the "G" Word

▼

"Harriet McCoy" was never imprinted on a charge card or a driver's license. I can't even imagine Grandma's face on a plastic square.

Grandma McCoy's dark brown eyes looked out over wire-rimmed glasses. Her gray wavy hair was always twisted in a bun on the back of her head. She ate meat, potatoes, and oatmeal to keep her strength up even when she was ninety years old. *Practical.* She gave the word a living definition.

She was my mother's mother, a working woman, a Christian working mother, a thinking person. She was hardly a mover and shaker by the standards of today's working women, but she has challenged my thinking about changes, employment, roles, and needing God.

THEN AND NOW

I wish Grandma could see my desk. It's a microcosm of the differences in our lives. Grandma died at age ninety-seven, nearly two decades ago. If she could step into my world for just a few hours I think I would be richer. We could talk about all the changes—perhaps she could give me a perspective on my world that's hard for me to grasp on my own. *I could use your*

help, Grandma. I'm trying to make it the best I know how, but I could sure use your help.

I can imagine her picking up our family portrait, taken eleven years ago. Her keen eyes take in my husband and our four preschoolers. Her glance rests briefly on the turned-up nose of the grandson who reflects her features. She studies my face, understanding the smile touched with fatigue so common in my expression at that stage of life.

Then she turns to the current family picture tucked in the corner of the frame, tilting up her chin to look down through her bifocals at the wallet-size image. "They look healthy enough," she mutters to herself. "That one's a little thin." She chuckles—"that one's got the dickens in that grin. He'll keep 'em on their toes." She carefully sets the frame back down exactly where it was (the rest of the desk is covered).

I show Grandma my employment contract for the coming school year. In her day, that kind of legal arrangement was only for men. What kind of extreme circumstances, she wonders, have forced me to go to such lengths?

Then she looks at my planning calendar: covered with appointments for my full-time job . . . nights blocked out for a graduate class . . . scheduled to the max with children's practices and lessons . . . dates noted for my husband's travel. "Well, I guess you don't need a porch swing anyway," she comments. "Wouldn't have time to sit in it."

The bits and pieces all over my desk are glimpses of our lives. My daughter's college tuition bill—a seventeen-year-old girl in another state! Bills, the checkbook, charge cards—all in my name. If Grandma lived my life for just one day, what would it feel like to her? Would we have any common ground?

Her world was so different. Born in Kentucky and orphaned as a child, she grew up in different households. She married young—perhaps her way of trying to establish her own secure roots, but it was not to be. She and Grandpa moved to Indianapolis to escape the poverty of farm life, but Grandpa was injured working on the railroad. The pension

was small. Then he developed diabetes. They didn't have food stamps or social security back then like we do now. Fortunately, her health was better than his. While her children were young, she began selling garden vegetables to supplement their income.

I can picture her on the street corners and at the grocery markets: a large, broad-shouldered woman with work-worn hands pushing a heavy wheelbarrow loaded with the produce of her labor. It's hard to believe that once she was seventeen, with a trim and girlish figure and a seventeen-year-old's dreams of a good life ahead.

Then and now.... Grandma would have loved to have had the education that I've gotten. Her library was a McGuffey reader and the weekly paper she and her neighbor shared. Her fingers never touched a typewriter; a word-processor would mystify her. She never drove a vehicle, although she took pride in the number of states she'd seen by train. She never owned property until Grandpa died.

I don't think she sat down and talked with her children about adolescent issues. But then Mother and Uncle Reid were never confronted with options that my four teenagers now face. Drugs were bottles of medicine you bought for illness. Peers were the few friends from the neighborhood whose families shared similar backgrounds and values. There was never enough time left over after chores to have to figure out how to spend it. The sheer physical demands of raising her children eclipsed the amount of emotional energy needed to guide their paths to maturity.

Did Grandma ever have to worry about competence on the job? Well, sure—she had to read the almanac for planting seasons and pray for the rains to come at the right time. She had to get her produce to market before it spoiled. Now we have to go career-exploring, job-searching, personal-inventorying. We swing astride dizzyingly steep learning curves.

Was life really simpler back then? I start feeling the keen edge of our differences. I wish that parenting issues didn't have to be so complex. *Then and now.* Our lives seem so different.

Grandma looks out of place in my world.

Then she picks up my Bible. It falls open to my favorite places, the pages dog-eared and vaguely stained. Common ground. She's in my world now. She knows about my life.

JUST GOD AND ME

Needing God—surely that's the strongest connection between then and now. Grandma and I share the same Bible, although we possibly come at some of its passages from different perspectives.

I want to ask this wise old woman how she read the Bible, what she thought of God's perspectives on women's work, how she followed the Lord through her daily routines and demands. Did she really work and parent without the guilt that dogs the footsteps of working mothers today? Did she feel a freedom that I long for?

Right now I'd like to hear Grandma's strong, reassuring voice telling me the story of her spiritual journey. I want her to mine her experience and wisdom for the essence of God in her life—the barebones of how God led her through life's challenges. Maybe what I really want is the reassurance that even five decades ago—then as well as now—God was relevant. I think it would strengthen my faith in His ability to build on the present for future generations.

But Grandma's not here anymore. Mama's not here anymore. It's just God and me. I roam through the Scriptures with my questions and my guilt. *Tell me it's okay, God.*

Of all the challenges we face today as working mothers, the greatest seems to be the question, *"Am I doing the right thing? Should I listen to this nagging guilt? Is it valid?"* So much has changed. Has God changed, too? Must He? In order to be God to Christian women today, to Christian working women with children, does His plan for women have to change?

ARE WE DOING THE RIGHT THING?

I talk with my friends who are working. We lament our loss of discretionary time. We wish we had more energy. We wish

we could order a clone to meet all the demands we can't keep up with. But most of all, we want answers for the guilt we feel. We want assurance before God that we're doing the right thing.

I believe Scripture gives us the answers and the assurance. Second Corinthians 7:10 speaks of two kinds of guilt, true and false: "Godly sorrow brings repentance that leads to salvation and leaves no regret, but worldly sorrow brings death." *True guilt is the conviction that we have violated God's commands.* It is real, and we have earned it. God created us with emotions that, if reasonably healthy, respond in predictable ways to what happens in our experience. We are capable of feeling true guilt when we do not follow His principles. Though our feelings may harden and our conscience may become unresponsive, most of us usually experience the pang of conscience when we go against God.

The counterfeit emotion for this is *false guilt*. When we violate other people's expectations, we feel the same emotional response as when we disobey God. But it's not valid, because, as the apostles boldly proclaimed to their questioners, "We must obey God rather than men" (Acts 5:29).

False guilt entangles us because the feelings it produces can be just as painful, just as upsetting, and just as immobilizing as those that produce true guilt. But in this case we suffer for the wrong reasons.

Are working moms doing the right thing? Each of us, of course, makes decisions in different ways for different reasons. We all suffer true guilt as well as false guilt. But the fact that we're working mothers doesn't automatically mean that we're doing the wrong thing. In my opinion, *most guilt felt by working moms is false guilt.*

WHY FALSE GUILT IS FALSE
The God I have come to know assures me that I can leave guilt behind. We working mothers *can* work guilt-free. This does not solve all of our dilemmas, add more hours to our day, or resolve many of the tough issues we face. But it lays to rest perhaps our

biggest struggle: dealing with the "G" word.

Hurrying home from work one night, I glanced at one of those signs over a donut shop that has clever weekly sayings: "Woman's place is in the home, and she'd better be there right after work!" *Very funny*, I thought as I had to downshift suddenly to avoid running into a curb that was rapidly approaching my car. (My driving is worse than its usual bad when I'm angry.)

That sign said it. Though society tolerates us in the workplace, most or all of the responsibilities in our homes are still squarely on our shoulders. It's a Catch-22. We're not welcomed gladly in the marketplace, and we're not released freely from our homes.

It would take two moms to be both places at once in full gear—at home, with lovin' from the oven served up in a freshly cleaned setting, children going out the door with matching clean socks, volunteering to work Saturday morning at the school fun fair. Some of us have tried to live as though we were two people. Long ago I came to the conclusion that with my limited energy and twenty-four hour day, it's impossible. But false guilt still creeps in whispering, "You should. . . ."

Why is this false guilt false? Because God doesn't give sole responsibility for home and children to women. According to Scripture, family structure is like a hammock between two parents. When I read the Bible, I observe men teaching their children and women working in the fields.

But our society has allowed families to become lopsided, separated, a mutation of the unity and shared responsibility originally intended. We've internalized the pattern and set our expectations accordingly.

False guilt imposed by society has a close cousin: self-imposed false guilt. Sometimes we feel we MUST do something or feel guilty. Probably no one else will see it, and if they did, they wouldn't care! But we MUST do it. It's past midnight, we're exhausted, and the world is sleeping—but we MUST clean that spot on the back of the basement closet. We MUST dust the top

of the bookcase. We MUST make something homemade to send with the kids to school tomorrow.

Perhaps what MUST be done should *not* be done right this minute. Or perhaps it could be done by someone else. Homework supervision? How about Dad or an older sibling? "But they might not do it as thoroughly as I." We have to have a hand in every kettle. "I might as well do it. I *should* do it."

Sometimes I ask myself, "Who am I trying to impress?" God doesn't need supermoms who are cranky, exhausted, and angry. He just wants real people doing what matters for eternity first, and other things "as needed." If the God of the universe loves me because I'm His daughter, what do I need to prove?

Enter the third cousin to societal guilt and self-imposed guilt: the Christian community. In *Women at the Crossroads,* Kari Torjesen Malcolm describes what she observed in our country after being on the mission field for several years.[1] She perceptively identified the constraints imposed on the body of believers. A major effect, she noted, is that women were no longer exercising many of their God-given gifts.

It's not my purpose in this book to examine the errors in interpretation that have brought about this sorry state, or to draw conclusions about what women can and should be doing in the church. Others have already done so, such as Malcolm in the book I just mentioned or Miriam Adeney in *A Time for Risking.*[2] But it's important that we understand how this confusion has affected women entering the marketplace.

The effects of restrictions on women in many Christian communities are widespread. Chief among them are false guilt and low personal esteem. We have internalized a mindset that causes us to question our ability, the gifts God has given us, and whether and where we should use them.

As a biblical corrective to the view that women's sphere of influence should be limited to home and children, I suggest we look at the examples God provides. Scripture abounds with stories that highlight the leadership, organizational skills, and judgment of women in spheres other than the home—for

example, Phoebe, Abigail, Deborah, Anna, and a host of other godly female individuals. Through studying these role models, our false guilt can give way to God-confidence.

Scripture teaches us that we are each given different gifts, strengths, and abilities. In light of that truth, consider the parable of the talents (Matthew 25:14-30). The master gave each steward an amount to invest "according to his ability." The steward who was given ten and used them wisely was commended. The steward who received five was commended equally for doing the best he could with what he was given. But the unfaithful steward, who received one talent, was punished. Why? Not because he pushed his limits. Not because he took a risk or miscalculated. He was condemned *for doing nothing*. He did not use even the small amount that had been entrusted to him—he just buried it in the ground.

When I look at God's expectations instead of other people's expectations, I feel a burden of false guilt lifted from my shoulders. I feel a new freedom and strength in the knowledge that I am investing my talents and gifts. God gave me abilities that I can use in the marketplace as well as at home, and I'm using them. It's like being a runner and stepping up to the starting line—then feeling the miles roll under my feet. Doing what we were created to do feels good.

Do you feel overextended? One burden you can get rid of is false guilt. Don't let it bleed off your energies—the tasks you face are demanding enough without the extra drain of taking on other people's heavy expectations of God's plan for your life.

I believe that working mothers today, perhaps more than ever, face special challenges. I think it's more difficult to work and parent than it used to be—and throughout this book we'll be looking at the specific issues confronting us. We need clear emotions and extra strength to do both—working and parenting—to the glory of God. We know that God would not ask us to use our talents to the detriment of the family. Let's find out together how to be faithful stewards with His investments for the good of all: women, children, and men.

MOM TO MOM ON DEALING WITH GUILT

The Supermom Syndrome
You don't need to do it all. Don't try to be Supermom. Remember this priority issue: since God does not tell us in Scripture that children are Mom's responsibility alone, you can share the load with other family members without guilt.

Those Things You Don't Get Done
When Jesus said "It is finished," there were still important tasks on earth waiting to be done. But Jesus had done what His Father asked Him to do. Focus on this thought: *You're responsible to do only your part, not everyone else's.* Working moms are not required to complete every important task.

Guilt—True or False?
How do you tell false guilt from true guilt when they so often feel the same? A helpful trigger for distinguishing between them is to ask yourself the question, *"Who am I trying to please, and why?"* When you recognize false guilt, decide to ignore it—or at least not to act on it. When you recognize true guilt, do something about it, get rid of it, and move on.

Understanding "Women's Work"

▼

"Mommy," Robby moaned, "my tummy hurts." I winced at the heavy tone in his usually bright voice. *This is the wrong day for you to be sick,* I thought to myself.

I was rushing through my morning, consumed with thoughts of how much was waiting for me at work that day. I had recently been hired as a client counselor for a relocation company — there were clients waiting for checks, a training session on contract variations, procedures to learn, administrative details that needed attention. But my first-grade son needed me too.

What were my options? Not many. Missing work today was out of the question. I was a new employee, the only one of the group with four children. I wanted — and for the sake of my job security, needed — to prove myself.

I took my business card from my suit pocket and tucked it into Robby's hip pocket. "Robby, you have to go to school today," I told him. "If it gets bad, go to the nurse's office and ask her to call this number."

My son slowly hoisted his backpack. As I watched him head out the door for school, I noticed that the usual bounce in his stride was gone.

I sped down the tollway. Questions . . . options . . . *guilt.* These thoughts filled the thirty-five minute drive to work. Once I stepped through the office door, however, there was little time to worry about Robby. Clients relocating, discrepant appraisals, divorce decrees dictating how home equity would be split, faxing checks—all gobbled the minutes of the day like Pac-man on a binge.

The next thing I knew it was after 5:30. As I stepped into the darkening parking lot, Robby's face appeared in my mind. How was he? Had the nurse tried to call? And then the bigger questions. As an adult, what would he remember of my nurturing and caring? How does it feel at six years old to shoulder your backpack and walk to school with stomach cramps? You can go back and unlock your house and go in. But nobody's home.

Something has to give, I thought. I needed to find a new solution—soon. Being a working mom worked fine when everyone was healthy. But I needed an alternative when one of my children was ill.

NEW CHALLENGES, NEW NEEDS

My dilemma with Robby was just one example of the many conflicts faced by working mothers. We're frequently torn between work pressures and family needs, between desire to do our best and guilt over whether we're making the right decisions, between new possibilities and old expectations. Where do we turn?

Perhaps the first step lies in recognizing that *working mothers need God in ways that we've never needed Him before.* Sometimes the need springs from desperate circumstances, such as a sick child coupled with an unforgiving workload. Or anxiety over the cause and the long-term effects of sudden changes in our children's behavior.

Other times it's steadily increasing pressure that moves us toward Him—increased fatigue, uneasy decisions about time priorities, subtle inferences from others that we're not making wise choices.

The changing circumstances of recent years have presented new challenges—and with them, new needs. We find we must know God in a new way, lean on Him for a different kind of strength, search for answers to questions we might never have asked before.

I think that one of our biggest obstacles in meeting these new challenges head-on is that *we lack perspective*. Changes happen too fast, and pressures are too unrelenting, to give us the time we need to put it all in perspective. We lack a guiding framework for the daily decisions that confront us.

Why is this perspective so important? Because it helps us understand that there are good reasons for what we're doing. When we make those late-night runs to the grocery store . . . gather up a load of wash with our last ounce of energy (to prepare clothes needed for the next day, hoping we'll remember to put them in the dryer first thing in the morning) . . . wonder if we'll ever again sit down to read a newspaper with a hot cup of coffee . . . ever feel rested and "caught up" . . . we'll at least have the assurance that our efforts are not in vain. We'll know that our hard work is accomplishing something important, something worthwhile.

I have this kind of satisfaction. Most working moms I know well enough to share more than surface feelings have this satisfaction too. But in the daily grind, we often lose touch with this feeling. And I've found that many people are sending the message that we shouldn't be experiencing this kind of satisfaction. So we push it a few layers down, and it ends up out of reach in the scramble for survival.

In the confusion of change, someone may suggest, "But don't you feel guilty?" We pause to consider as our emotions begin to stir. Maybe we do. Women, especially working moms, are good at feeling what others suggest they should feel.

THE QUESTION OF "WOMEN'S WORK"

In my opinion, the dilemmas of trying to be a working woman, a full-time mother and wife, and a household caretaker all at

once have not been created simply by women entering the workforce. They're the results of several decades of economic turbulence, changing roles, and fluctuating expectations in a society changing so rapidly that we're constantly moving into unknown territory.

It seems to me that we need a clearer perspective on what "women's work" really is. A healthy perspective on work can help us eliminate the false guilt we feel when we're pressured into thinking it's just "wrong" to be a working mother. It can also help us understand what the real needs are in our families that give rise to symptoms of guilt and anxiety. It's not just Christian working mothers who suffer from our society's confusion about women's work: most working mothers do. Single working women labor under the effects of past role restrictions.

A clearer perspective does not automatically solve the practical problems of day-to-day conflicts between working and parenting. It will not eliminate ethical problems or discrimination in the workplace. And it will not add any more hours to the day. But a clear perspective can ease the stress of change and help us make needed decisions for the future, sharing responsibility for the outcome—instead of just resigning ourselves to a daily struggle for survival.

ROLES VERSUS RELATIONSHIP

I want to propose a new perspective on women's work. I think much of the current confusion has been caused by a perspective that defines women's work in terms of *roles*. I suggest that we define women's work in terms of *relationship*.

Before we can move to this new perspective, however, we need an understanding of where we are now and how we got here. Let's look at how confusion over women's *roles* has contributed to confusion over women's *work*—which robs working women of the confidence they need to make choices wisely and to find satisfaction in their chosen paths.

I think there are three major perspectives on women's roles that are most affecting us today: (1) women's roles as

defined by social conditions; (2) women's roles as defined by authority figures or institutions; and (3) women's roles as defined by the Christian community. These tend to get mixed together in the assumptions about women's work that we often unquestioningly accept—consciously or unconsciously.

Roles Defined by Social Conditions

This perspective defines women's work according to what social conditions dictate are appropriate roles for women. For example, the presence of women in the workforce swelled during World War II and then diminished when men returned and went back to work in the post-war boom—and society's assumptions about the appropriateness of women in the workforce fluctuated accordingly.

The problem with this perspective is, of course, that times change—what works in one era may not work in another. But we tend to attach permanent importance (sometimes even Bible verses) to the definitions of women's work that arise from these changing roles, without realizing that we're basing our understanding on changing historical conditions—not on a sound foundation of truth.

Think for a moment about the sharp contrasts in women's roles from one society or time period to the next. I've often thought about how isolated women have been in recent decades in being assigned practically exclusive care for their children's upbringing (whether they were out of the workforce or in it). Dad earned the money and Mom raised the kids, according to the prevailing stereotype. But historically, this has not been the norm.

For example, anthropologist Margaret Mead has investigated cultures in which people live as extended families and villages assume more cooperative roles in the care of children. Women give birth and return to the fields hours later with their newborn strapped to their back. Sometimes three generations live together with elders, male and female sharing responsibility for children. Children are more likely to be at their parents' side, whether farming, fishing, making nets, or performing other

tasks necessary to the survival and economy of the village.

America's early agricultural years provides another example. Children were able to be with parents as they worked. Most farm work was done within calling distance of home.

With the growth of population, cottage industries sprouted up as people began to specialize to meet the needs of expanding communities. During this era, children still spent time with both parents. The family "industry" might be downstairs with living quarters upstairs. Children were not isolated with Mom while Dad went to work.

The industrial age brought major change to the family as it moved the workplace out of the home. Now Dad went blocks or miles away to the factory.

In the post-war years, city living spread to surburban living. Family environments were increasingly polarized. During working hours it was rare to see a woman in a factory, behind a bank counter, or in a boardroom. And it was equally unusual to see a man in a suburb during the day. At the same time families were moving farther away from grandparents, and offspring didn't settle near Mom and Dad.

As these social conditions changed, so did women's roles. Mothers became more isolated with their children. The range of what women did became narrower. Men were increasingly removed from the lives of their children as well as their wives. Ironically, the term "nuclear family" emerged during this era. But if we think that "nuclear" implies "close-knit," the term is not appropriate.

Today we are emerging from an era in which it was widely assumed that raising children was "women's work." Social conditions helped shape the perception that women's major role was to "stay home and take care of the kids." When women started entering the marketplace in large numbers, a great cry of alarm went up over their separation from their children. Why wasn't an alarm of equal volume sounded for the separation of fathers from their children? Partly because of society's confusion over women's roles and women's work.

A second source of confusion over women's work is the

perspective that it is defined according to women's roles as established by authority figures or institutions.

Roles Defined by Authorities or Institutions

This perspective makes assumptions about women's work on the basis of what government, religious systems, or other authorities establish as the roles women ought to perform.

For example, in some countries women are not allowed to obtain a driver's license or own property. This obviously restricts the work they can do.

Or, as in some religious systems, men decide when children will be born and how many the family will have. Women are restricted to the tasks of bearing and nurturing those children.

I've always been curious about how and why these decisions are made. I suspect that many of them made by those in authority have not always been based on the good of all. The benefit of the few—those making the decisions—probably prevails. Or perhaps the decisions are well-intentioned but simply misguided. But whether the decisions issue from the legislative authority of a governing body or the religious convictions of a sole individual, society needs checks and balances. One of the best systems of checks and balances is education: knowledgeable people, informed and literate.

Women's position seems to rise as their literacy rate increases. I wonder if that has been true in other periods of history. Luke commended the Bereans (see Acts 17:11) because they searched the Scriptures to see if Paul's teaching was true to God's Word. Most women in our country are literate. (Most women in the world are not.) One advantage for women in recent decades is their increasing involvement in Bible studies. We have been able to search the Scriptures, research the original meanings of words, and study the contexts of passages. In our desire to know better the God we love, we have become better checks and balances for those in authority.

This leads into the third perspective on women's work that has helped create our current situation: the understanding of women's roles arising from the Christian community.

Roles Defined by the Christian Community

Christian authorities, and the shared assumptions of the Christian subculture, are not immune to the misguided views or misuse of power found in governmental authorities and non-Christian religious systems. Here, too, our ability to search the Scriptures and seek God's direct guidance helps provide checks and balances for those in authority.

When we recognize the power of social conditions and authorities or institutions to shape prevailing views on women's contributions, it's not surprising that a similar effect would occur in the church's views on women. Christians often tend to adopt a philosophy of women's roles based on contemporary social conditions and customs.

During the last two decades, most Christian writing on women has centered around the issue of women's roles—either advocating "traditional" views of the role of women or protesting women's confinement to such views.

Evangelical Christians have tended to narrow the role of women, which has sometimes contributed to the family's separation and isolation along the patterns I described earlier. Yes, there are Scriptures instructing women to love their children and care for their homes. But those verses are few compared to the number instructing us to use our gifts in broader areas.

When the pendulum swings too far away from God's truth toward Christian assumptions that are distorted by social values, somebody suffers in some way. In the confusion over women's roles, many women have suffered with identity conflicts—inhibiting their ability to follow God's leading and sometimes resulting in anxiety and depression.

King Solomon stated, "A man can do nothing better than to eat and drink and find satisfaction in his work. This too, I see, is from the hand of God, for without him, who can eat or find enjoyment?" (Ecclesiastes 2:24-25). The term for "man" in this verse refers to male or female, so we can accurately use the feminine gender as well. He repeats the same wisdom later: "I know that there is nothing better for [women] than to be happy and do good while they live. That every [woman] may eat and

drink, and find satisfaction in all [her] toil—this is the gift of God" (Ecclesiastes 3:12-13). Again, the term used for "man" means male or female.

Why has the Christian community tended to overlook this scriptural understanding of work in its prescription for the roles of men and women? Satisfying work is an important part of our healthy well-being: this shouldn't surprise us. Even in the perfect setting of the Garden of Eden, God designed work to be done.

God has created us—men and women—to thrive on satisfying work: "Then God said, 'Let us make man [adam—male and female] in our image, in our likeness, and let them rule over the fish of the sea and the birds of the air, over the livestock, over all the earth, and over all the creatures that move along the ground'" (Genesis 1:26). Note that God said let *them* rule. Then He commissioned them: "God blessed them and said to them, 'Be fruitful and increase in number; fill the earth and subdue it Rule over the fish of the sea and the birds of the air and over every living creature that moves on the ground'" (Genesis 1:28). Note again God's use of the pronoun *them*.

The command to multiply and subdue was given to both man and woman as a team. But we have segregated the tasks and dismantled the team in the process. Tradition says "multiply" (raise a family) belongs to the female, and "subdue" (work outside the home) belongs to the male. Tradition says this, not Scripture.

Curiously, helper means "one you can stand face to face with," a position hard to achieve when roles separate male and female into separate spheres. It seems to me that God does not intend that men and women live such segregated lives.

When I recognize that God created me to subdue as well as multiply, it helps me understand the satisfaction I feel in working, the sense of accomplishment in getting a paycheck, the gratification from doing my small task in the marketplace. God created me to do it. No wonder it feels good.

But much of the Christian community has told us that women are not supposed to feel good about working. We've

borrowed assumptions from our society's views of appropriate gender roles and used them as a grid through which to interpret Scripture passages. Our concept of self-image has leaned heavily on Sigmund Freud's interpretation that men build their self-image on work (what they do), and women build theirs on nurturing (who they have relationships with). But men need involvement in nurturing relationships, and women need satisfaction in worthwhile work. The error of polarizing self-image as men's need to work (subdue) and women's need to nurture (multiply) harms all of us.

Many Christian working mothers have absorbed the understanding of women's work taught by authorities in the Christian community without questioning it in a responsible way, with Scripture as the ultimate authority. The perspective that authorities and institutions define women's roles can be especially confusing because of the Bible's commands regarding subjection to those in authority. The pastor is the "shepherd of the flock." The husband is the "head" of his wife, who should "submit" to him "in everything." Even presidents and kings can't occupy their positions without God's permission.

How do we balance this teaching with God's ultimate authority in our lives? How do we put it in the context of the overall teaching of Scripture?

These questions brought me to the new perspective on women's work that I think we're in desperate need of: it's defined not by *roles,* but by *relationship.*

A NEW UNDERSTANDING OF "WOMEN'S WORK"

I propose that we define our work according to our relationship with God—not according to social conditions, customs of a particular historical period, current authorities, institutional practice, or even the prevailing assumptions of our church.

"Women's work" becomes an appropriate term when it's based on the God-given talents and strengths He has given or chooses to develop in individual women. We should be making life choices and navigating through changing phases and needs according to what will best facilitate our use of those

gifts. Our understanding should begin with Scripture's account of God's creation of women and its record of God's comprehensive instruction to all humanity.

Once this is our starting point, issues of work are no longer part of a debate over "roles." They are part of determining our proper response to God's desire for our lives. God is our creator. He has ordained each day of our lives, and He is our first and foremost authority. Yes, I am part of a body of believers, of a family, of a local community, and many other conglomerations of people. But when I stand before God to give an account of my life, I will stand alone.

When Paul instructs us in Romans 12:3-8 to use our gifts, the phrase "every one of you" uses the Greek *anthropos,* male and female. The word "each" (verses 4-5) is all-encompassing. None of us has been left out, regardless of race, gender, or age. Both men and women receive gifts. I fear, though, that more women than men have been hiding them.

First Corinthians 4:1-4 has long been my challenge and my comfort in this area of responsibility before God: "So then, men [or women, *anthropos*] ought to regard us as servants of Christ and as those entrusted with the secret things of God. Now it is required that those who have been given a trust must prove faithful" (verses 1-2). I can't blame my unused talents on someone else's idea of what I should do with my life. I can't point my finger at cultural pressures. He tells me in Romans 12:2 that I should not be conformed to this world. I don't want to be like the steward who hid his talent in the sand, even though my talent may seem insignificant. That unworthy steward hid his talent because he was afraid. It is frightening to make an investment — especially when that investment is yourself.

The challenge of using our gifts might seem awesome and impossible if Paul's instructions in 1 Corinthians 4 did not also include God's criterion for measuring success. He simply asks that we be *faithful* (verse 2). He alone knows the hurdles that each of us must overcome to exercise the gifts He has given us. He alone knows our potential, our limitations, and the effects

of our environment. Thank God that He alone is our evaluator. Society measures success in dollars. But God counts unpaid service, honesty, and many other criteria our culture has been unable to get a handle on.

When women's work is understood from this perspective, many women ask, "What are my talents? What does God intend for me to do?" A good question—and we'll spend the next two chapters exploring how to answer it. There are many tools available to help us know ourselves and our special inclinations.

The place to begin, however, is with the knowledge that *God created you like no other person* (see Psalm 139). You have a particular personality or God-given bent (Proverbs 22:6). All of these factors will impact your work.

Men my age usually spent their adolescent years experimenting to discover their strengths and decide what kind of work they wanted to do for a lifetime. Women my age were most often preparing for marriage and exploring the kinds of people with whom they were compatible. They gave little thought to developing personal strengths. Both the employment and family scene would probably be better today had expected roles not dominated back then.

Fortunately, times are changing. Women today are exploring their talents and interests more thoroughly. Men seem to be increasingly concerned with relationships. The challenges they face are also changing. The restrictions are dissolving under the pressure of realities.

▼

My Grandma Hatie McCoy never knew she was supposed to stay within the "biblical" roles for men and women, so she used her God-given talents freely, where and when they were needed. Our family recently discovered a list she made of all the different kinds of work she did in her lifetime. She titled it "The More Abundant Life of Hatie." Here are a few excerpts from her list:

> Some things I have done and helped to do—all kinds of farm work, including plowing, hoeing, ditching, grubbing, mowing, binding, and cutting grain by hand . . .

breaking, training, and blacksmithing horses and mules, feeding and taking care of farm animals; clearing new ground and burning off same, sawing down trees and splitting them into rails, posts, boards, and shingles; making spokes and ax handles; hauling rails and building miles of rail, and other kinds of fences . . . making gates, bars, doors, barrels, wagons, and wagon beds; building dry-kilns of stone and drying pears, apples, and peaches on same; laying foundations, erecting and moving buildings, painting, digging cellars, carpentering, making maple sugar and syrup . . . spinning wool into yarn, weaving, braiding rugs, knitting, crocheting, embroidering, tailoring, mending shoes . . . taking wheat and corn to mill on horseback, making soap, butchering, curing and canning meat . . . general orchard work, making cider and vinegar, jams and jellies, pickles, relishes, sauces . . . raising poultry, beekeeping, assistant clerk in a department store, nursing the sick and washing and dressing the dead; hunted and trapped wild animals and game birds . . . cooked on hot coals, wood stove, coal stove, gas, and electricity.

Grandma McCoy didn't view her work as survival drudgery; she saw it as abundant living. She was proud enough of it to write it down—and what I've listed here is only part of it!

I watched my grandmother's large, rough hands rub dirt from a big turnip before laying it in her wheelbarrow for market. She obviously loved the soil and the produce of her work with it. I have a mental snapshot of her climbing down the ladder propped against a cherry tree. With a wry smile, her gray hair escaping from her bun in all directions in the humid heat of southern Indiana, she glanced at the bucket brimming with bright red fruit and quipped, "Not bad for an old woman."

In her expression I saw great satisfaction in her work. Decades later, I can still visualize those intense dark eyes flashing with interest and pleasure. Not bad, Grandma Hatie, not bad.

My seventeen-year-old son must have caught a glimpse of that same expression in my eyes when we met for lunch. He drove to meet me at Grady's Greasy Spoon, where we sat over bowls of their indescribable chili (a dish I always vow never to order again). John commented on my work, "You're better for us when you're doing something you like."

I thanked him for meeting me. Inside, I gained strength from his affirmation of my work. "I like being able to call a counselor direct," he went on. "And Grady's is like a special bonding."

We laughed. Grady's was special all right, and so was my relationship with my son. I thought of those working mother survival decisions I had made in the past. Not bad, Miriam, not bad.

MOM TO MOM ON UNDERSTANDING OUR WORK

The Changing Family

Let this fact relieve your feelings of false guilt: *Working moms are one small force in the changing family.* Change is a given in our world today, and it's fueled by many different sources. Whether it has positive or negative results often depends on the eyes of the beholder.

Let's encourage each other with some of the positives of our experiences as working moms. When the negative results of change are pointed out, we need not assume guilt by accepting those results as our fault.

Changing Roles

Sorting through changing roles means sorting through our own past. Have you ever tried to close a messy, disorganized file drawer? First you have to file the material in appropriate categories so the folders fit neatly. Then you can close the drawer.

Understanding our attitudes about our work and our roles involves understanding our past. That requires putting our past in order so we can close the file drawer and get on with our future. As you reflect on the influences that have shaped your

understanding of women's work, try to identify the roles you may have learned from: (1) your family—parents, siblings, aunts and uncles, grandparents, or close family friends; (2) religious influences or community, past and present; (3) any groups or institutions influencing your life. Then ask, "How well do these roles reflect the instruction and examples in Scripture?" Use this information to help you make decisions about how you should respond to changing roles.

Change in Yourself

Give yourself permission to change in how you view your work, your contributions, your life directions. Use an unchanging foundation for making choices: the priority of your relationship with Jesus Christ as Lord, personal friend, and mentor.

Finding Your Fit in the Marketplace

▼

Where do you fit in the marketplace? How do you know where to start looking for the job or career that's right for you?

These are the questions we'll explore in this chapter. Let's start by inviting some others to the kitchen table—women who want to reenter the workplace, moms in need of survival money, those who are seeking professional growth and development.

Pass the coffee and open up your thinking.

"I want a better job," explains Janet, a retail clerk with two teenagers.

"I just want a *job*," exclaims Nancy, "—any job, period!"

Marie, a line worker in a factory, tosses out, "Wouldn't it be fun to have a job you really loved?"

"What can I do with the kind of background I have?" "Can I earn decent money?" "How do I know what I'm good at?" Questions bubble up like the percolating coffee.

Much of what I'm discussing with you in this book focuses on parenting. But in this chapter we're going to focus on jobs—what we can do in the marketplace—by looking inside

at ourselves and outside at our opportunities.

No matter how old you are or what kind of job you have, as a working mother you inevitably have to sort through work issues as they relate to parenting. Perhaps you're just beginning to ponder a career, or reevaluating the one you're in now. I want to help direct your thinking to the opportunities that are out there.

START SOMEWHERE

Have you ever daydreamed about the kind of job or career you'd like to have? Ever pictured yourself in that ideal setting—until the picture began to fade as other considerations pushed it off the screen? Many things can crowd out personal dreams . . . lack of experience or education, financial demands, personal doubts, just plain not knowing where to start. But I want to encourage you, *Don't lay aside your dream*. Maybe at least some of it can be woven into reality sometime in the future.

Remember that David started off as a shepherd with his staff . . . advanced to a soldier with a slingshot who was too young and slight to borrow Saul's sword to battle the enemy . . . and later, as a seasoned solidier on his way to an eventual kingship, commandeered Goliath's sword (undoubtedly much bigger than Saul's) with the words, "There is none like it. Give it to me" (1 Samuel 21:9). Scripture encourages us to use what we have in our hand in the beginning, to be faithful with our small skill, our seemingly unimportant position.

David started out "small"—as a little brother. Through increasing opportunities for responsibility, he became a shepherd, hunter, warrior, motivator, leader, and king. Interwoven throughout his "career" pattern he was also a musician, poet, friend, and father. Yet he also suffered through a period of "unemployment," when he was on the run from Saul, apparently sidetracked from his mission.

The diversity in David's vocational path is echoed in the marketplace today. On average, people change career paths four times during their working years—and the average is probably higher for women who bear and parent children.

They enter and exit the job market more frequently than men, often switching careers upon reentry.

Entering the marketplace as a young woman is less difficult and less stressful than reentering after months or years of focusing on childrearing. My twenty-year-old daughter might dispute this—young women have no easy task trying to match abilities, options, and dreams with the array of choices now open to them. After completing three years of college, Valerie has changed her major five times and is still searching.

Women reentering after the parenting stage face additional challenges of an "aged" degree and sometimes low self-confidence for trying something new. I wish I could give all of you who are in the reentry stage a big hug and a hearty "Hang in there!" I've survived that experience. I was shocked, disappointed, and angry to find that my degrees in education and varied experiences did not reopen the position I wanted in secondary education. Wasn't teaching supposed to be a job you could always go back to?

But I hadn't done my homework. Enrollments were declining. I hadn't "kept my foot in the door" by substitute teaching or continuing to take education courses. The door was closed. My résumé wasn't short—just antique. I entered my leapfrog stage hopping from one lily pad to another.

If you're not in either stage of launch or reentry, perhaps you're currently in a job or career that doesn't quite fit you. Our black Lab, Magic, was ferociously territorial in protecting our property—as more than one repairman can testify. Oversized and loyal, he loved to be patted and encouraged. But Magic felt he should climb into our laps for affection. This personality quirk was mismatched to his large, muscular breed. Magic struggled and dangled while trying to maintain his perch. He wasn't meant to be a lapdog.

Have you ever had a job that just didn't seem to fit the way you're made? Expectations and abilities don't match up. You want something else, something more. It's time to explore different options; some internal clock seems to be approaching

the hour of passage. You're ready for change. You're entering a stage of transition.

Regardless of the varied circumstances—such as launch, reentry, or transition—that send us out in search of a niche, we all have much in common. Our success in responding to opportunities depends on some common denominators. Let's take a look at them.

YOU HAVE SOMETHING WORTHWHILE AND UNIQUE TO OFFER

The truth of your individual value is based on a firmer foundation than the power of positive thinking or a new mental outlook. Scripture proclaims this truth about you.

Several years ago while I was rummaging through the Word to find a basis for a positive self-image, I discovered Psalm 139. God made each of us as individuals. Each of us is different. Each of us is valuable. This means each of us has something worthwhile and unique to offer in the marketplace or in any other niche—whether in the body of believers, our local community, or society.

Some of us are creative. (I'm not.) Some of us like to learn. (I do.) Some of us have physical differences that enhance our employability, such as dexterity or strength or endurance. Some have initiative—while others are waiting for boredom to set in, they're formulating a plan, thinking of alternatives, and taking step one while planning step two. And then there are finishers, who have the ability to take hold of another person's idea and plod along—working, working, working—until step one is finished.

Some women are communicators. They effectively bridge space between human beings over miles of telephone wire or satellite communication. They have a heightened sense of feeling for where others are, an uncanny connection. They have that rare ability to accept each person where she is, forming bonds with others of different ages and stages. Do these traits describe you? They're foundational strengths in sales, group presentations, leadership, and public relations work.

Leaders are another group with unique characteristics. Research indicates that women and men lead and manage in dramatically different ways. One woman president of a broadcasting firm describes herself as a transmitter, a leader picking up signals from everywhere and beeping them out to where they need to go. Women leaders stress sharing information, and see themselves at the center of things. Men leaders see themselves at the top of things.

Women whose strength is the ability to learn, frequently have a desire to explore something different. That rolling stone may gather no moss, but it does break into new territory and explore new terrain. With the proliferation of information and the continual change in employment opportunities, this can be a worthwhile characteristic. We all have the ability to learn to some degree, but some of us thrive on the challenge of newness. This can motivate us to research, to expand, to find new ways to complete an old task. It's a marketable characteristic.

The list of our unique characteristics is endless. What's most important is for you to *believe* that you have something unique to offer. Reflect on these passages from Scripture:

> For you created my inmost being; you knit me together in my mother's womb. I praise you because I am fearfully and wonderfully made; your works are wonderful, I know that full well. (Psalm 139:13-14)

> We have different gifts, according to the grace given us. (Romans 12:6)

> Now to each one the manifestation of the Spirit is given for the common good. (1 Corinthians 12:7)

No other person can contribute to community, family, church, and marketplace exactly what you can contribute.

In addition to your unique strengths, you have another advantage. In the last several decades, our economy has boosted employment rates over previous periods. You have more opportunities to affirm and expand your abilities. The information age has increased the diversity of job possibilities. The corpo-

ration is not the only way to go; small companies are reviving and surviving. Here and now is a good time to discover your marketability.

Some of you may now be mothers at home without a steady job or position in the marketplace. You may feel that parenting will be your only career from now on. But statistics tell us otherwise. Most women will be employed during some part of their lifetime. Currently, most return to the marketplace while children under eighteen are still at home. With this reality in mind, consider your parenting years as fertile ground for self-discovery and personal development in preparing for an eventual involvement in the marketplace.

Are you actively considering entering, reentering, or shifting your place in the workforce? Let's take a look at some marketplace realities.

STAY ALERT TO THE CHANGING EMPLOYMENT SCENE

Will Rogers once said, "When you're through changing, you're through." Those words contain more truth today than when he said them. Your success in finding where you fit depends in part on recognizing changes in the marketplace and how those changes impact you.

A generation ago, women did not have opportunities such as telecomputing, telemarketing, paralegal work, or software designing on their career list. (Assuming they were considering career choices.) In the move from the industrial to the information age, computers have become integral to most work in some way. To keep up with change, you should at least become familiar with computer terminology. In my opinion, it's vital to develop minimal skills—whether with basic computer language or word processing—to demonstrate your compatibility with this tool. You need not own one to learn. Most libraries have computers available for use. Junior colleges and adult evening schools offer inexpensive courses with hands-on experience.

In addition to developing some level of computer literacy,

I also urge you to become familiar with what sectors of the economy are growing, and general trends that enhance the job market. Books such as John Naisbitt's *Megatrends* (Warner Books) or the annual revision he writes with Pat Aburdene (William Morrow and Co.) describing the year ahead are helpful resources, especially in identifying expanding and declining areas of the marketplace and providing a bird's-eye view of global trends.

I think some of the most critical trends influencing the job market are the drastic changes in today's family and the education of *all* our youth, not just the middle-class. The expanded population over age sixty has impacted work opportunities from geriatrics to travel. The increased number of women working has affected the fast-food industry and the whole food processing and marketing industry. Awareness will not secure a job, but it will help alert you to areas with a good outlook when you sort through options.

Much of our country's job growth is in the service sector. Health care and fitness are providing many new jobs. By 1995, 53,000 computer technicians will be needed, and business will be looking for 800,000 building custodians.

The pace of change continues to escalate. If you were to graduate from a technical college this year, in five years half of what you learned would be obsolete. If you were to graduate two years from now, half would be obsolete in only two years. The average worker will hold ten jobs and experience two to four career changes in her lifetime. We might as well get comfortable with the search for our niche in the marketplace.

Perhaps by now you've decided to stop searching. When the speed of change is dizzying, the discomfort of where you are now can feel easier to handle than the feared unknown. But don't be discouraged: as mothers, we're change experts. Our lifestyles demand it.

The fact that we bear children and have traditionally been their primary caretakers means that we experience drastic changes. We gave up eighty percent of our allocatable time on

the delivery table with our first child. We parent and nurture without taking courses in Midnight Feedings 101 or Refereeing Sibling Rivalry 808. We experience the same cycles as men in personal development and change, but intertwined with them are the cycles of our children, to whom we may be symbiotically bound for better or for worse. We are forced to learn flexibility and adaptability.

Whether we've become adept at adjusting to change out of necessity or natural inclination doesn't matter. We have that tool in our hand, and we can use it on new turf: the marketplace, serving the body of believers, or volunteering in our community or nation.

FINDING YOUR FIT IS A PROCESS

A statement tacked above my desk has encouraged me through many transitions: "No successful person has been launched directly from obscurity to notoriety, as if shot from a cannon. There have been years of planning, preparing, exploring, learning, failing, retrenching, relearning, and trying yet again. But most of all, such people had the courage to give whatever they wanted a whirl." I don't remember who said it, though I recall that it was a woman. She spoke as though she'd been through what we're experiencing now. My abbreviated version of this wisdom is: The Process Takes Time.

The American Way is instant. Instant soup. Instant service. Instant success. I don't patronize some fast food chains because they don't make my English muffin as quickly as McDonald's. I want near-boiling water from my faucet so that quick-cooking rice cooks more quickly. The American corporation wants quarterly profits even if it jeopardizes the future of the company. The only place we tolerate great globs of time consumption is on road repairs.

Our predisposition to speed drifts over into job-finding patterns. I mentioned earlier that I failed to do my homework when I wanted to reenter the profession for which I had originally trained. The planning/preparation period may be tedious and sometimes discouraging, but it is vital.

I want to suggest three steps for your career-planning process. First, *take a personal inventory.* It can be as brief as a typing speed test or a comprehensive battery, as informal as your own subjective evaluation of yourself. Many assessment tools for interests and skills are available at libraries and bookstores. For example, books designed to help you identify the abilities and experiences that can guide you into the marketplace include Richard Nelson Bolles' *What Color Is Your Parachute?* (Ten Speed Press, 1991) and David Frahm's *The Great Niche Hunt: Finding the Work that's Right for You* (NavPress, 1991). Popular magazines carry abbreviated versions that may uncover ideas for further exploration. Junior colleges provide inexpensive services from personal assessments to seminars and counseling for individuals to explore their abilities.

Don't dismiss the idea of exploring your values and interests—it's not a self-indulgent detour. People who like what they do are happier, healthier, and often more successful.

Some of your interests and skills will be obvious to you. Others are less obvious but just as valuable. These might require a little prodding, or perhaps a crisis, to bring them to the surface.

My Bible assumed new value for me as I was taking personal inventory. I began to see people in Scripture as individuals/workers. Abigail was an organizer/diplomat. Priscilla was a scholar/tentmaker. Esther was a model/negotiator. God created each of these women uniquely, and they glorified Him through their work. He has not changed. We can trust that He created us with the abilities and strengths to glorify Him in our work.

After taking personal inventory, the second step in the process of finding where you fit is to *match occupations and careers with your interests and abilities.* What positions match what you want to do or can do? Books, magazines, and the job section of your local newspaper will help you in this stage.

Some people find that "just right" job easily. My friend Annette parented four daughters and had entered the grandmother stage. She began praying for a job that would utilize

her abilities. Her personal inventory included artistic talent and organizational ability. She had always been one of those craftsy people who give marvelous, ingenious gifts of her own creation. The seminars she planned ran smoothly, often because she anticipated glitches and solved them in advance. Annette asked the Lord to include travel, if possible, when He moved her toward a niche in the marketplace.

I literally ran into Annette in a shopping mall. "Oh, Miriam. I have the most marvelous job!" She had been hired by a tall women's shop (she met that criterion also) as assistant manager and window-display coordinator for the entire chain. "And they're sending me to a convention in Canada!" Her husband was going also. She sparkled as though they were departing on a honeymoon.

One woman was able to open her own boutique with funds that came just when her youngest started kindergarten. But most of our dreams don't materialize so quickly. I wouldn't recommend waiting for the ideal job to fall into your lap. God can work in that way, but He may choose to provide a more circuitous route for you. One advantage of a long searching process is that you will appreciate that eventual position in which you can use your abilities all the more, and you may have time to integrate it more thoroughly with other responsibilities in your life.

Keep in mind that the hours you spend studying want ads, making phone calls for advice, networking, and conducting informational interviews can all be a part of refining your skills as well as your patience.

A friend of mine has spent six years studying to become a Registered Nurse. Does that sound like a long time to pursue your plan? She was single-parenting five children part of that time, and working in the hospital during her training. What motivated her to be worker, student, and parent during those years of little sleep, little money, and even less discretionary time? She wanted to be a nurse! She had always wanted to be a nurse. She decided that she would never arrive unless she started the journey.

Obviously, my friend won't enter her chosen profession at age twenty-two with a lifetime to enjoy it. But forty-five isn't bad. It's a whole lot better than never.

If the job you want involves complex skills or qualifications, you may need to acquire experience in different areas in order to be competitive in that market. Your plan may include accepting a job that is not your "ultimate" in order to gain valuable experience. Or working with certain people or companies to benefit from their expertise. But do stick to a plan, even though you may not follow it precisely or find yourself revising it frequently. A plan can encourage you to keep following a dream when you otherwise might be tempted to give up.

I found this out through experience. When I reentered the marketplace, I completed interest inventories and listed my skills. I studied the want ads and was called in for a few interviews. I prepared a résumé that met the criteria of the guide I was using. In fact, I conducted five informational interviews to become more at ease with the interview process.

The result of this effort over two months was zero.

I called a friend to moan over my plight. "I feel like a dinosaur. I'm too old. The fifteen-year interlude in my work experience looks bad." Grumble, grumble, grumble.

Mary did not give me any magical answers or hot phone numbers. She simply told me, "Hang in there." Sigh.

But Mary's advice worked; eventually a door opened. Five years and many jobs later, I finally settled into a niche that seems right for me now. I share my experience to encourage you. We are not dinosaurs; sometimes it just takes more time and effort to be discovered.

We can look forward to the prospect of finding new niches as our lives move through changing seasons. As Christians, we have great potential for growth and freedom to overcome weaknesses because of our Enabler/Creator. This does not mean bigger, better, and richer. Elijah graduated from a high-profile prophet to a quiet professor for his successor. Ruth's public moment of truth and faith was in her youth; we hear little of her later years.

This side of heaven, we may never know which stage of our lives brings most glory to our Creator. We needn't know. If we're using what He's placed in our hands, He will take care of the rest.

Today may find you in the marketplace part-time combined with training or schooling. You might be three levels away from where you want to be. Maybe you're selling your hand-painted sweatsuits at craft fairs, flea markets, and home parties instead of the downtown boutique or your own shop. But you've started. Keep going by evaluating your progress occasionally. Pull out your first inventory. Are you using some of those abilities? Are some needs being satisfied? Are you moving toward your goal? Better to admit you're off course than to devote years aiming at the wrong target. It's easy to be busy rowing in the galleys and forget to climb up in the crow's nest to see if the ship is still on course.

Midstream course changes can be necessary for many reasons. You may enter a field and discover options you hadn't considered before. You may have ruled out more schooling because you lacked funds—but fifty percent of businesses provide funds for further schooling, and you may get hired by a company that will help pay tuition bills. God uses so many methods to direct us that I would not dare to attempt to summarize or categorize them. *When we acknowledge Him as God, His changes will result in good.*

I doubted this reality when I was changing jobs frequently in my leapfrog stage. Looking back, however, I realized that I learned a little about real estate, moving personnel from state to state, and special education cooperatives, all subjects unknown to me before. I met people, made friends, and discovered more of my husband's loyalty and my children's resilience. I am a richer person (speaking non-dollar-wise), albeit with more grey hair because of those changes.

Though each situation is different, evaluation is important for all of us. Time spent looking at your work, your circumstances, and your abilities, gifts, strengths, and weaknesses is time well spent. It can reveal unnecessary use of time, open

up possibilities previously beyond your reach, and sometimes identify sources of frustration. Evaluation is an important part of the process of finding your niche.

GOD-BLESSED SATISFACTION
IS AN ACHIEVABLE GOAL

We all share the desire for satisfaction in our work. God created us that way. Comments such as "It's just a job," or "It pays the bills," or "It keeps me busy" reveal that under the surface, we—women as well as men—really want to like what we're doing.

As I studied information on employed women, I came across some interesting facts. Working outside the home has a positive influence on the well-being of women. Busy women who combine job and marriage tend to be healthier than those who are either unmarried or unemployed. Additionally, the so-called superwomen who add children to the responsibilities of job and spouse are just as healthy as those who don't have to deal with offspring. Finding our fit in the marketplace doesn't mean being fated to end up between a rock and a hard place.

Women are gifted by God with personal strengths and abilities. We're functioning in more varied positions in society than we have for years. Many non-profit organizations enriching the fiber of life in our society are staffed and led by women. Three-fourths of the women between eighteen and sixty-five are in the workforce. Nearly 60 percent of the women with children under eighteen are there too. When we exercise our God-given abilities, we experience a God-blessed satisfaction.

Christian women can be in the front of this expanded opportunity to use their gifts. We have opportunity to know ourselves in relationship to our Creator and Redeemer. We are living in a time when we are free to choose, and we have the promise of God's loving guidance for our lives. Finding our fit may be a process, but God has uniquely equipped each one of us for the journey.

MOM TO MOM ON FINDING YOUR FIT

"Is There Really a Place for Me?"
If you find yourself discouraged about your job search or career plans, hold on to this truth: *You are special.* Not because you're a mom, but because God made you. Think big, think small, think different. God created you for a reason, and He will use your uniqueness in the marketplace as you respond to Him in loving faithfulness to His leading.

"How Do I Know
What I'm Good at Without Work Experience?"
Taking a personal inventory doesn't have to be a big, involved project. Try carrying a small notebook around with you. Divide it into two sections: "SKILLS—What I Can Do" and "INTER-ESTS—What I Enjoy." Write down thoughts or ideas as they occur to you throughout the day. Look for personal strengths, whether related or unrelated to parenting, and be alert to what you can learn about yourself.

"What if I'm Stuck in the Wrong Job?"
Where there's a will to change, there's a way to do it. Shift your mental set from rigid assumptions to flexible anticipations. Use the suggestions in this chapter to get you started on a plan for finding out where you fit in the marketplace. Hang in there!

Pursuing God's Plan for You

▼

I sit down at my desk to write while the world is still dark and quiet. It's too early for anyone to be up yet—myself included. But this is the only time I have right now to get anything done outside of the immediate demands of job and family.

My thoughts briefly escape to a fantasy. . . . I'm up in a mountain chalet somewhere, sitting down to my fine wooden desk in front of a big picture window at a decent hour of the morning when my brain actually wants to go to work instead of back to sleep. I've already had my wake-up cup of coffee, and I'm sipping my second, luxury cup as I relax and collect my thoughts for the writing I will do today. Our household nanny is busy in the kitchen, washing leftover dishes and feeding the troops. I have time to think, time to write, time to spend with my family in all those creative, "if I ever get the chance" kinds of ways. . . .

Keep dreaming, Miriam. Actually, stop dreaming and get to work—before this time slot is up and you have nothing to show for it.

I'm not a writer by profession. I do it—as I do just about

everything else—in the trenches, as a full-time employee and parent of four teenagers. I don't have the clarity of the big picture from the mountaintop, and I don't have the ease of taking my time to search out answers slowly and thoroughly. I simply have to do it on the run.

Isn't this the way it is most of the time as we seek out God's plan for our lives?

We wish we had His plan all laid out before us, the details of the landscape and the twists and turns of the trail clearly visible through the big picture window. We wish we could ponder our decisions over a relaxed second cup of coffee, with plenty of time to pray and get advice and research those opportunities that are just waiting to be explored. We wish the demands and pressures would take care of themselves while we prepare for what lies ahead.

But most of us have to pursue God's plan on the run, in the midst of surviving day to day. We don't have the luxury of starting out with a clean sheet of paper—no complicating history, no commitments or entanglements to narrow our field of vision, no tangle of factors to make our decision-making process difficult and complex. No, we're already in motion—fast forward, mostly—and we have to work with what we've got.

But what we've got, in the midst of the daily struggle, is God Himself. And He's planned more for us than just getting by, just making it through. "A woman can do nothing better than to eat and drink and find satisfaction in her work. This too, I see, is from the hand of God, for without Him, who can eat or find enjoyment?"

We pelt Him with our questions.

"What direction should my life take, Lord?"

"What is Your plan for me, for our family, for where we should go and what we should do?"

"How do I know that what *I* want to do is what *You* want me to do? Can I have it all?"

His still, small voice speaks more powerfully than thunder. "You have Me, My child, you need nothing else."

Ultimately, satisfaction for men and women originates not

in the home or the marketplace but from the hand of God. Let's look at some key areas in pursuing His plan for our lives — doing what God made us to do in the press of day-to-day living. Satisfaction and survival issues will inevitably intertwine. I think it's helpful to group the issues in three categories, through which we'll explore how to merge goals with realities:

- Present covenants (i.e., commitments you now have in place), primarily marriage and children.
- Location and community.
- Guidelines for seeking God's will in making life choices.

COVENANTS

The concept of "covenant" seems foreign in our society. We tend to take promises and agreements lightly compared to other cultures. The English word, literally meaning "coming together," signifies a mutual undertaking between two or more parties, each party binding itself to fulfill obligations. In the New Testament, the word is used as an alternative to "promise." In the Old Testament, *covenant* primarily signified a disposition of property by will or otherwise, and did not in itself contain the idea of joint obligation. Covenants usually signified an obligation undertaken by a single person.[1]

The Bible does not use the term "covenant of marriage," though we hear it in many wedding ceremonies today. We can safely say, however, that God sees marriage as an important agreement between two people, one which most of us enter by choice. Other books expound on the characteristics of a successful marriage. My primary purpose is not to review how to build a Christian marriage, but to examine how this covenant affects our marketplace decisions.

The fact that you are married will impact your work. What you give at the office is not available to be given at home. Any promise signifies obligations; marriage is no different. This is true for men as well as women, except that in our society there are more binding obligations assumed on the part of the woman's time than the man's.

I skim the employment section of our paper because I'm interested in what women do. I have recently noted that women graduates of law schools (and some men) do not necessarily stay in the profession, even though they have invested many years of training—and expense. The number of lawyers who leave the profession each year equals the number who annually graduate from law school. It's common practice for young lawyers to work seventy-hour weeks in order to earn partner status. Many are deciding it is simply not worth it. There's more to life than marketplace work.

Part of the "more" is marriage. If you're married, *talk, talk, talk* about your desires, opportunities, and the possible consequences for both of you related to different decisions. Read *The Dollmaker* (or better yet, watch the video together), by Harriete Arnow. If you don't exercise gifts as individuals, there will be unhealthy consequences in the marriage.

You may choose to trade off wage or salary rates for a job flexibility that will enhance your marriage. The parable of the workers (Matthew 20:1-16) illustrates that the value of our work is not tied to its earning power, in contradiction to society's values.

Your marriage is unique, and therefore your covenant and marketplace involvement may be different from all other marriages. No two marriages are alike, because no two people are alike. What frees two people to pursue separate careers is not always evident.

Perhaps you've married Mr. Mom, or a man who loves to cook. My freedom to work has been enhanced not because I married a chef (his menu choice is "Which Drive Thru?"), but because my husband "mobilizes the troops." He's an expert at delegating laundry tasks, floor-washing, meal clean-up, and clutter removal. Our daughter and sons have learned as much from observation of him as from his direction.

Characteristics of your unique marriage and the fit between your and your husband's individual temperaments and abilities will impact your involvement in the marketplace.

Marriages usually survive some periods of time when one person must devote large amounts of time or emotional

energy to his or her work. Wise working women—and men, too—monitor the pulse of their marriages. I know of one thriving marriage in which one lives in the Midwest and the other on the East Coast. They have no children, and both seem to thrive on travel.

But most of us need more togetherness. Jerry Jenkins' book *Hedges* (Wolgemuth & Hyatt, 1989) offers excellent material on protecting a marriage. This protection seems especially important when both spouses are in the marketplace. Work and a bigger arena of acquaintances offer diversons that can be healthy or destructive, depending on our choices.

Children will impact your work. Just as marriage changes your life, so does becoming a parent. You are never the same again. And you shouldn't be. Ideally, bringing children into the world means entering into a covenant with them.

This covenant is the bottom line of who's responsible for our children. Ideally, all sectors of society should be involved in protecting children's welfare—from extended families to the marketplace to local communities and state and national government. Unfortunately, this ideal has not become reality in our country today. Responsibility rests heavily on Mom and Dad with little other support.

If your husband shares this support mutually, wonderful. But if you parent alone or nearly so, remember that *no one else can be your child's advocate as well as you can be.* Yes, children are flexible and resilient. They can grow through difficult periods and the emotional demands of your work. But monitor the effects of your decisions on them carefully.

Discovering God's individual plan for you as a woman includes childbearing by choice. Despite some views that couples should simply "let the children come," I think there are good reasons for the decision to remain childless or to deliberately limit family size:

Availability for ministry. Paul taught that a person could remain unmarried in order to devote time and energy to the Lord. A married couple may feel that God's primary calling for them individually or together is to ministry that cannot be

combined with family responsibilities.

The presence of hereditary illness. Tay-Sachs disease, hemophilia, and Huntington's chorea are examples of genetic illnesses that when dominant in a child, irrevocably alter that family. Some couples may choose either to adopt or to remain childless when these conditions are present.

A severely dysfunctional family background. Through God's grace, some people from severely dysfunctional families have been able to marry and become parents and break the generational thread of dysfunctions from alcoholism, sexual abuse, abandonment, and violence. But others have not. We come to Christ from all kinds of places and experiences; we come to marriage similarly. We need to allow people the freedom to go before God with their broken past, their memories of rejection, their terror of violence, their fear of their own temper, their addictions—and ask His direction and guidance. Then we need to accept and love them as brothers and sisters, humbly walking our different paths.

When both spouses are committed to strong career goals. If a couple devotes desire, drive, and life focus to their respective careers or professions, it may be wise for them to choose to have no children—or at least plan carefully around a small family. Some couples can pursue demanding careers and parent successfully; others cannot. No amount of quality childcare, schedule strategies, or material amenities can make up to children for the decrease in parenting time or withholding of emotional involvement that can result from a demanding, dual-career marriage.

Children are a choice, a covenant not to be entered into lightly. You can become an ex-spouse, but you never become an ex-parent. Long after your résumé is obsolete, they will still be your children. Consider your covenant to your children as you make work commitments and choices.

LOCATION AND COMMUNITY

Sue had been a foreign language teacher for ten years. She and her husband wanted a child, but both were fearful of combin-

ing parenting and two careers. Her income was the greater and more reliable; neither had flexible hours nor the possibility of part-time work in their current positions. They were equally convicted that any child they might have should receive quality nurturing.

A Christian woman in their community, who had mothered eight children herself—some born to her, some adopted—operated a home center for children. Her center was licensed and in high demand; the infant waiting list was long. Sue and Ryan put their name on the list and planned the birth of their child to coordinate with Sue's summer off and the time that their reserved spot would be available. Such planning would have stunned my Grandma McCoy.

If you're planning to have children while continuing your career or work, look carefully at your community for what help will be available to you. You might also consider a job change for the benefit of childcare. Increasingly, the needs of working parents have taken on heightened prominence. Businesses are now aware that their employees' problems in arranging care for their children may result in absenteeism, tardiness, low morale, and decreased productivity. As a result, many employers are considering change in their personnel policies to avoid these problems. These changes may include direct benefits, such as employer-sponsored daycare, assistance with childcare costs, or information and referral services for community childcare resources and counseling services. Indirect benefits sometimes include flexible work schedules or leave policies, voluntary shifts, or part-time status.

In general, the workplace is becoming more flexible—too slowly, but at least it's happening. There are more opportunities for self-employment, temporary work (even at the professional level of medical doctor or lawyer), job sharing, and independent contracting than we have seen since the agricultural era.

Collectively, these trends are referred to as the "contingent workforce." Working mothers can take advantage of these options—or create them, if possible. The disadvantages usually

involve reduced benefits, compensation, and opportunities compared to those in the traditional model. But as working moms we're used to living with compromise anyway—and traditional employment in the marketplace requires negative compromises as well. The contingent workforce offers flexibility to employer as well as employed—a precious, priceless commodity for working moms.

Research the options in your community. In one small town the going rate for a competent caregiver is an affordable eight dollars per day. Employment opportunities in that town are limited, but some working moms there have found it a workable compromise. Childcare and employment options in most locations are changing, and your investigation time is well worth the effort.

GUIDELINES FOR SEEKING GOD'S WILL IN MAKING LIFE CHOICES

During one of my own searches for God's will, I came across the following simple guidelines and found them very helpful for evaluating career options and job choices:

- Does it benefit you personally?
- Is it beneficial to others?
- Is it a worthwhile investment of your resources?

Does It Benefit You Personally?

I took an informal survey of working moms with the question, "What is the personal benefit of your work?" Many listed financial reasons—no great surprise from the statistics, since three-fifths of working moms are doing it to survive. But after that reason, here are some of the other answers I heard.

"Work is my safe place with rational people," one mom told me. Her family was dysfunctional and her husband frequently irrational. Work gave her a place out of the isolation of home to see how other people in the world lived—to get a reality check on her circumstances at home. Work helped her maintain a healthier self-image.

"It's hard to describe," another said. She made silk flower arrangements for weddings and other special occasions. "When I look at what I've made, I feel whole." This is an example of God-blessed satisfaction—the ability to do what God created us to do. Her work and her home reflect the creativity God instilled in her.

A mom who works on a line in a large bakery commented, "It's my ministry. I think of the people who will enjoy this. I pray for the hungry people of the world, especially the children." She came from another country where hunger is common. "My work is not monotonous," she said. "How can serving the Lord be boring?" I have seen few women gain as much satisfaction from their work as this sister.

I'm a list person. I've sometimes found it helpful to write down the ways my job is beneficial to me. This becomes my thanksgiving list.

Is It Beneficial to Others?

If we receive a paycheck, our work must benefit someone or we wouldn't be paid to do it. However, a paycheck is not a measuring stick for how beneficial our work is. Society sends us this message, but it is inaccurate. Remember the parable of the workers referred to earlier? Those who were hired late were paid the same as those who worked all day. This parable brings consternation to our "American Way" mindset.

It was work for Mary to wash Jesus' feet, work for Martha and Mary to cook for Jesus and His followers, work for Priscilla to teach Paul. Were they paid for it? No.

Benefit to others is not necessarily indicated by price tag. I purchased the best cinnamon roll I have ever eaten in a small town in northern Wisconsin for a quarter. In my area, I'd have to shell out $1.75 for a stale imitation.

Another benefit of working moms' work is health insurance. Marie's wage is small, but her medical and dental benefits are excellent. Her husband is a self-employed landscaper, and those benefits would be prohibitively expensive if purchased for one family. Thanks to the benefits of Marie's job, their five

children have regular dental checkups and adequate care for illnesses and injuries.

Elizabeth is paying for her two children's university education. She wants her children to work with the benefit of a college degree—which was unavailable to her. (Though I wouldn't be surprised to see her bring a sheepskin home before she's fifty.) Chandni sends money to her family in another country. She supports four relatives there and hopes to bring her younger sister to join her.

How do others benefit from your work? You may provide goods, services, beauty, or information. You may bring benefits home—things that money *can* buy—that you couldn't afford otherwise. Or you may bring home a diversity of experiences and information your family members wouldn't get anywhere else. My sister's family shares a vocabulary with terms such as "Quimper," "Wooton desk," "Depression glass," "Shaker," and many others because of her work with antiques.

List the benefits of your working for others. You will have another thanksgiving list.

Is It a Worthwhile Investment of Your Resources?

"Why?" I can't tell you how many times I hear that word in our household. It's often followed up with, *"What's so important about that?"*

Actually, these are questions that should be in good standing with us working moms. In fact, I think we ask ourselves these questions more than most because our hours have so many demands on them. As a regular practice, we have to scrunch and streamline our tasks. We need to know whether we're making a wise investment or throwing away our precious time.

I read about a poll taken in 1989, in which respondents were asked to identify the most important goal for the women's movement in the next decade. Number one was *helping women balance work and family*. We know that our paychecks don't last—the dollars disappear like butter on a pancake griddle. As we search for God's plan on the run through

our busy days, we frequently question how to spend the finite resources of our lives.

Shirley Mulling has her own clothing store in a Chicago suburb. From fashion designing to store management, purchasing, parenting three daughters, and being a pastor's wife, Shirley struggles for balance. But she lives with inner confidence that the talent God gave her is not buried.

She models her faith in their church, El Calvario, to other Hispanic women. Her goal for her daughters is that they become strong Christians, obtain an advanced education, and pursue a career.

In the quest for balance, Shirley advises, "Don't try to be a Supermom. You can serve leftovers with love. Plan each day the day before to minimize surprises. Then pray and give that day to the Lord." She employs Christian women, encourages them, and spends as much time as she can with her family. Even with her well-ordered priorities, Shirley says sometimes she is too tired to pray.

I know how that feels. I asked her what she does when she reaches that point. "I call a friend and ask her to pray for me. It's a must!"

Shirley is not throwing away her time. She is investing her resources wisely with God-honoring results—not the least of which are three daughters who are observing her commitment and benefiting from her service.

Is your work, or your plan for the future, worth the investment of your resources? If the answer is yes, your thanksgiving list is longer. If it's no, then it's time for change.

Sometimes a "no" answer is rooted in work that in some way might violate a clear Christian conscience. A friend of mine found a way to make changes from within her job, rather than leave it for another position. She worked for the refund department of a transportation company. When she began the job, only one-third of the justifiable refunds were being made. Clients with large accounts did not examine or request refunds due them; other refunds were made unjustifiably. After pondering and praying, my friend went about her job

thoroughly and well, based on Christian values of competence, fairness, and honesty. She did so without knowing what the consequences would be to her personally—but it turns out that she eventually received several promotions.

When our work does not violate our Christian conscience or require us to go against the teaching of Scripture, our investment in it can become the fulfillment of a spiritual calling. I referred earlier to a Christian woman who has a licensed daycare center in her home. She loves children and feels her compassion is a God-given gift. I know Christian educators in public schools who see their work as their calling to be salt in the world. They see their professional choices as part of pursuing God's plan for their lives.

As you take your thanksgiving list to God—the benefits of your work to others and yourself—ask Him for direction in the choices before you. Talk to other Christian working moms. We gain much from asking our questions out loud and listening to others express their views. We learn of other options, how God has worked in other circumstances. Our faith grows and our vision of God expands.

Discovering God's individual plan for our life fleshes out God's instruction for teaching our children about God. Mothers everywhere want to care for their infants, nurture and supervise their adolescents, and establish lifelong positive relationships with their children. But Christian working moms want more. We want our children to love our God, who created them. We want our children to obey the only loving Power who can lead them through satisfying days.

We can instruct our children by reading Scripture to them. We can worship with them in our body of believers. We can talk to them about the God we love. But we can impart our convictions to them on a profound level by the way we live our lives. Some learning occurs only through observation. Our children observe our search for God's direction in our choices. They see our Bibles get pulled off the shelf and opened up for guidance and refreshment. They hear our prayers and listen to how we talk about our work relationships.

In a truly Christian two-parent family, the hammock is equally held between mother and father. Our children will see us work, rest, minister, and parent as one holder of the hammock. A working mom, yes—but also a person using her gifts, strengths, and the hours of her day as she believes her God wants her to. As we pursue God's plan for our lives, we will implant in our children the desire to do the same, as they face increasingly weighty decisions in the maturing process. Perhaps this spiritual training by observation is the greatest heritage of all.

MOM TO MOM ON CRITERIA FOR WISE CHOICES

Keep a Healthy Perspective
Making wise choices depends in part on maintaining healthy perspectives. In chapter four we explored your uniqueness as an individual, created by God. This is an essential understanding for shaping your action in pursuing God's plan for you.

To keep this healthy perspective, go back and read Psalm 139 periodically. Dwell on the phrases "fearfully and wonderfully made" and "days ordained for me." Trust these truths for your life as a woman with days to live, energy to expend, and gifts to use. Let them be the bottom line of your balance sheet as you explore how and where to invest the life God has given you.

Check Your Actions
One sure criteria for making wise choices according to God's will is to check your actions against Scripture. Do they square with the Word of God? Are the steps you're taking toward a goal consistent with what the Bible teaches?

I find 1 Corinthians 4:4-5 helpful for testing my activities against God's will for me: "My conscience is clear, but that does not make me innocent. It is the Lord who judges me. Therefore judge nothing before the appointed time; wait till the Lord comes. He will bring to light what is hidden in darkness and will expose the motives of [women's] hearts. At that time each will receive [her] praise from God."

Evaluate Your Motivation

Pauls speaks of "the motives" of our hearts. We need to ask ourselves *why* we're doing what we're doing. Here's a key question to ask yourself in evaluating your motives: "Do my attitudes and reasons for taking this direction or making this decision fulfill the law of love?"

Calibrate Your Directional Compass

Pursuing God's plan for our lives is rooted in becoming the kind of people He wants us to be. As you evaluate decisions and directions, set your compass according to God's purpose for you as an individual created to reflect His image in all you do. Rely on prayer and your best understanding of how you are uniquely made to express His life in yours. Then as you come up against a decision point along the road, ask yourself, "Does this direction fit His calling for me?"

Getting Together: Moms at Home, Moms in the Marketplace

▼

How can I describe being a mother? "It was the best of times, it was the worst of times." Charles Dickens captures it in his opening lines of *The Tale of Two Cities*. The exhilaration of victory, the agony of defeat. The heritage and gift from the Lord, the most thorough and ongoing test of patience and endurance.

All mothers share this mixed blessing. You might think this common ground would draw us together to share experiences, fears, opinions, speculations, solutions, failures. You might think in the exhilaration of victory, we would unite in celebration; in the agony of defeat, we would cling to each other for support and encouragement. You might think we would weep and sigh together, laugh and chuckle — or sometimes just sit together in the silence that speaks our awe or sorrow when words fail to describe what we feel.

But for the most part, we don't.

Most mothers feel isolated. One mother told me, "I was new in the neighborhood. I didn't know a single other mother I could talk to. There didn't seem to be any other babies." With the average birth rate of 1.8 per family, she may have been

right. In past generations, supposedly Grandma was nearby, and there were quilting bees or coffee klatches where mothers could listen, learn, and share notes on how to parent.

WHY WE DRAW LINES BETWEEN US

In the first quarter of 1990, 7,724,000 mothers who had children under six years old worked outside their homes. This represents two-thirds of the mothers of preschoolers. These mothers experience much anxiety. Their anxiety mounts as the flood of reports increases about the importance of the first three years of a child's life. These mothers think stay-at-home moms see them as inadequate moms, moms who have abandoned their babies during precious years that cannot be repeated.

We often overlook statistics indicating that two-thirds of working moms must work for survival, and that violence, poverty, and other factors impact preschoolers—*all* children, for that matter. However, working mothers are quick to grab the burden of guilt, not considering that the great majority of them are doing the best they can, making the best choices given their circumstances.

If they could not work, many single working moms would be forced to choose hasty second marriages, which tend to be high-risk, just to avoid poverty.

But stay-at-home moms are no strangers to anxiety, either. They can feel under pressure to raise "super-kids" just because they're THERE. But they may not be equipped to raise super-kids, even if such a thing were possible to do. They may be unhappy to have left a career; they may miss the second income they contributed, and worry that the family won't be able to afford the special lessons, schools, and experiences that super-kids should have. They may feel that moms in the marketplace think they're less capable, energetic, or aggressive than the "nineties" woman is supposed to be—relics stuck in the past.

Mom at home feels isolated, and in fact she may be. Americans are on the move—literally—every three years. So she must

make new friends, and most moms are not home. She may watch her neighbor strap baby into the car seat, scramble back into the house for baby's bag, her purse, and a cup of coffee, and then drive out of sight. She may think that once at work, working moms talk about their children—the most educational toys to buy, how to soothe teething pain—in a stimulating and satisfying environment where they mingle freely and easily with other professionals.

Not so. When the marketplace mom has a hairbreadth of time from the phones, the computer, the charts, or the machines, she must call to make the next pediatrician's appointment, phone the daycare center about a change in work hours, dash to the nearest pharmacy for ointment (or aspirin for herself), or make a grocery list for restocking the ever-deficient refrigerator and pantry.

CLOSING THE GAPS

So moms in the marketplace and moms at home feel isolated. They contemplate their differences and feel anxiety about their circumstances. If they do share time and conversation, they may spend it in some form of defending their decisions rather than discussing their common experiences and concerns.

The gaps between moms in the marketplace and moms at home seem to be opening rather than closing. Unfortunately, churches sometimes widen the gaps and increase the anxiety rather than offer assistance, encouragement, and solutions to the respective dilemmas of working mothers.

I have an opinion on why this gap exists and why it's so difficult to overcome. For several decades, one of women's greatest mountains to climb was that of internalizing healthy self-esteem. Though it's not my purpose in this book to address this topic in depth, I will briefly offer my coffee-klatch counselor opinion.

Because we're emerging from an era in which roles have traditionally been narrowly defined, many of us have not realized that we're uniquely created by God with gifts, abilities, and strengths that can be useful in a variety of places. We tend

to base our personal esteem on relationships—either with those we depend on, or with those who depend on us. This tendency leads to insecurity and uncertainty about our identity, and difficulty in seeing ourselves as special and precious to God.

In this state we enter the marketplace, motherhood, marriage, and many other areas of life. Because we're unsure, we're sometimes defensive. Are we doing the right thing? Change has come rapidly, and we have few role models. We want to ask questions, yet we're afraid of revealing our ignorance. We think *we're just supposed to know*—especially where mothering issues are concerned.

To make matters worse, our internal anxiety is aggravated by the external bombardment from our society on everything from wardrobes and household cleaning supplies to children's study skills and "meaningful" vacations.

As I see it, the task of raising children is becoming more difficult. Our position as mothers is as important as ever. *We need each other.* We need to communicate—all of us, at home, at work. Essential issues for all children—healthcare, education, safety, nurturing—demand our cooperative effort, because they are not being resolved very successfully or adequately right now. We need to band together for the sake of the children.

Our black house cat, Zilgan, had escaped outside and was ruffling the feathers of the birds in our yard. I looked out our bedroom window past the cardinals' nest in the privet bush. A cardinal was bursting her vocal chords chirping and scolding while hanging on to a worm in her beak. How she held her babies' next meal, sounded the alarm, and kept Zilgan at bay was quite a feat.

I fear that too often we're chirping and fussing at each other, marshaling our defenses of what we're doing. And while we sputter in our insecurity, the babies are threatened.

What do we do about our differences? How do we close the gap? How do we become unified?

I sat down one day with my coffee and Bible, reading Galatians. I pondered the differences that came between Peter and Paul. *Their differences were like ours,* I thought. *They were*

called to accomplish different things in God's Kingdom work. This passage gave me some ideas about how we can start erasing the lines we've drawn between us.

First, we can recognize that *God is at work in different individuals in different ways*: "For God, who was at work in the ministry of Peter as an apostle to the Jews, was also at work in my ministry as an apostle to the Gentiles" (Galatians 2:8). He has created us uniquely. Doesn't it make sense that He can direct us to glorify Him in different ways in different places?

After God creates us uniquely and calls us to different areas for ministry and work, *He gives us grace for the assignment.* "James, Peter and John, those reputed to be pillars, gave me and Barnabas the right hand of fellowship when they recognized the grace given to me" (Galatians 2:9). To be a mother in the marketplace or at home takes grace these days. Grace is God's unmerited favor. I like to define it with the acrostic, "God's Riches — Abundant, Constant, Eternal."

Jan is a Chicago lawyer. Her daughter, Sara, is two years old: eager, affectionate, smiling, delighted by music and clapping. Jan takes the train out of the city on Monday night lugging two briefcases full of paper. Tuesday morning she is up early, working at her computer until Sara awakens. She faxes finished work to her office, then bathes and feeds Sara. They go through exercises and Jan talks, describes, coos, and cuddles. Because Sara has Down's Syndrome, they are off for morning therapy, which will increase Sara's dexterity and her ability to communicate. Jan knows Sara will read, learn, communicate, maybe ride horses or swim, maybe go to college — the things other children do, maybe more.

After lunch together, Jan puts Sara down for her nap. Then it's back to the papers, the computer, and the fax machine. Due to an unexpected event, Jan needs to go into the office in the evening. Jan's husband meets her at the train station; Sara smothers them both with moist kisses and a smile a mile wide. Then it's off to the city in the dusk to prepare for a trip to San Francisco the next day. She catches the last train out of the loop, lugging the ever-widening briefcase. *Klickety-klack,*

klickety-klack, take a nap, take a nap. Sara smiles in Jan's reverie as she dozes for the forty-minute ride.

Grace. For energy and a clear mind after commuting, for Sara's wakefulness at night, for Jan's questions about Sara's future, for questions all mothers ask. This working mom needs God's grace for her assignment.

▼

One hundred three degrees, the thermometer reads. Charles lies flushed and listless. *Case number two of strep,* I think, *and the older two with chicken pox. It would have to happen during Chicago's worst snowstorm of the winter.* My husband is out of town and can't get back home—O'Hare Airport is closed.

The hours seem to drag on endlessly. Calls to the pediatrician, the pharmacy. "Is your street plowed? Can you meet our driver at the corner?" I can order prescriptions for four sick children, ages six and under. But my fingers do the walking in vain through the yellow pages for a twenty-four hour laundress to recycle the sheets and towels of a sick family.

Pans by the bed, a cool hand, a sharp ear to hear a weak call—energy for the moment is the grace I need right now.

For my sanity's sake, I shovel the driveway—twenty-four inches of snow needs clearing. A few minutes alone here and there, a breath of crisp chilling air, the opportunity to use muscles cramped from sitting on the edge of one bed after another.

Grace, it's called. Grace for the time of my life when I was a stay-at-home mom.

I think it's time for moms at home and moms in the marketplace to reach across the gap to each other with the right hand of fellowship. We're all dependent on God's grace in our individual circumstances. As we communicate, I think this common dependence will become refreshingly evident. We'll gain a new appreciation of the challenges that each of us faces, a new understanding of the joys and struggles in meeting them.

Can't we agree that God has called us to different places of work utilizing the different gifts He gave us and the different life circumstances in which we find ourselves? "They

agreed that we should go to the Gentiles, and they to the Jews" (Galatians 2:9).

Interestingly, after Paul, Peter, James, and John had agreed to accept each other's differences, they looked outward. "All they asked was that we should continue to remember the poor, the very thing I was eager to do" (verse 10). When we can't accept each other's differences, our focus turns inward. But when we stop draining off our energy defending our position, we can spend it where it's really needed: on our families.

Just for a moment, substitute "children" for Paul's mention of the poor. Here's an imaginary paraphrase: "They all agreed that some mothers were called to the marketplace; others were called to volunteer service in church or community; still others were called to minister primarily through their homes. All they asked is that we should continue to focus on the needs of our children, the very thing we were eager to do."

In a real sense, our children are in a similar category with "the poor" Paul mentions. They're dependent on us for survival from conception. Without a caring, nurturing adult, they make their debut on Planet Earth without an advocate. They can't make their voice heard on Capitol Hill. They don't set policy for our educational institutions. They can't put bread on their plates. And sometimes, they can't even tell us where and how it hurts.

Let's go beyond the issue of why we take different directions, and share our mothering experiences—we have much to gain from each other.

LEARNING FROM EACH OTHER
I've learned more about parenting my children's different temperaments from listening to other mothers than from any other source. I've learned to identify the earliest signs of different illnesses and borrowed tips on how to respond and comfort.

The most excellent referral service you can access for child-oriented dentists, pediaricians who listen and discuss options, orthodontists who consider your child a person instead of a

policy number, and any number of other vital pieces of information is: *other mothers*.

A comforting byproduct of this communication is that our gnawing feeling of isolation will start to fade. Of course, some sense of isolation is a condition of being human. It will never be completely gone until we're in heaven, united with our Creator. But meanwhile, sharing what we have in common helps.

Here are some examples of how we can learn from each other. The 1988 "Directory of Self-Help and Mutual Aid Groups" lists more than sixty parent groups in the Chicago area. "Family Focus" offers classes in child-rearing, but their major thrust is to provide a comfortable place for mothers with children under four to spend time chatting with other mothers while their children play. One of the support groups listed in the Chicago directory has four thousand members. Numbers don't tell the whole story, of course, but they do illustrate the need. Churches that want to minister to families might consider creative outreaches for meeting these needs.

But we don't have to wait for structured opportunities to learn from each other. We can be alert to the possibilities around us, to the one-on-one exchanges that can happen spontaneously in the course of our relationships.

Margaret and I sit together in my porch swing. Two women, both forty-four, both mothers. Margaret, a mom at home now, has a graduate degree in journalism. She is a master at "looking about." She sees more in the world and in people than most of us notice. She captures it on paper, in her journals, and with her camera. One hundred and twenty-eight picture albums of her family line her bookcases, and she's only been married twenty-two years! I don't know how many journals she has. I, a mom in the marketplace, am a "learning in the trenches" writer, trying to communicate to other women what spills over in my life experiences. We meet today to share the swing, share our lives. Margaret's two-year-old daughter, Louisa, drops "nana" bread down the chipmunk's hole. Margaret pats her soon-to-be-born seventh child.

Our days are quite different. When I'm beginning my

quiet, early-morning commute at 6:45 to the office, Margaret is making breakfasts, packing lunches, organizing carpools, fielding questions. She has flexibility for involvement in her children's school meetings and has devoted more volunteer hours to her church than I will ever be able to give.

But today in the swing we're not talking about our differences. We're talking about our eldest sons. Through her eyes, I see a young man's search for adulthood and independence. I learn from her experiences of the interaction of dad, mom, and searching son. We, too, are a family with dad, mom, and searching son. After our time today, I am encouraged. I have new approaches to try, new strength to persevere patiently.

SHARING THE BURDENS, SHOULDERING THE LOAD

"Carry each other's burdens," instructs Paul, "and in this way you will fulfill the law of Christ" (Galatians 6:2). Then he flips it to the other side: "Each one should test [her] own actions. Then [s]he can take pride in [her]self, without comparing [her]self to somebody else, for each one should carry [her] own load" (verses 4-5). These verses complement each other. They apply beautifully to mothering.

"Burdens" (*baros*) means a weight—anything pressing on one physically or making demands on one's resources, whether material, spiritual, or religious.[1] *Baros* means heavy: the burden is easier to bear if it's spread out among many.

Certainly children press on us physically and make demands on our resources: materially, emotionally, spiritually, financially. According to some estimates, it costs over one hundred thousand dollars to provide for a child from conception to adulthood—not including costs for higher education.

Spiritual demands of motherhood are beyond measure. This fact alone often keeps us coming back to the throne of grace to share our burdens with the Lord. I find it difficult to believe that after birthing or adoption, a mother could watch a child grow, and remain an agnostic. I think a prayer would escape her lips when she sees her child step unexpectedly

into the street; enter school that first day; lie feverish, fitful, and undiagnosed; stay out past an expected hour of return late some night; or pack that bag and move out. I find that I *must* lean heavily on my Creator. Some of the heavy burdens of mothering are too weighty for human shoulders alone.

As our nation and society push God out of our structures—schools, families, judicial system, and national policies—I fear that more mothers will crumble under the burden. *Baros* were meant to be shared.

What does Paul mean, then, when he instructs each person to carry her own load? *Phortion,* the word for "load" used in verse 5, means something to be carried; but it does not have the sense of heaviness that *baros* connotes. Jesus spoke of His *phortion* as light (Matthew 11:30). This word was used for a soldier's pack—a portion that one must carry alone.

What must be carried alone? The bottom-line responsibility—to parent our children the best we can instead of abandoning them. But the unshared burdens of parenting have become so great that some mothers (fathers too) have literally given up on parenting. They've thrown the whole load off their shoulders.

Some babies end up without a loving adult to claim them and care for them. Our family became intimately acquainted with this tragic reality many years ago when we adopted one of our sons. Shortly after birth, he had been placed in a boarding home after leaving the hospital. He was in limbo—released from his birth mother but not yet cleared for adoption.

Our son's hospital instructions included "allergy to milk: needs soybean formula," but nobody was paying attention to them. When our adoption agency got involved, they were billed for the procedure of circumcision, but the surgery had never been performed. Robby came to us drinking a milk formula, losing weight, and suffering from a diaper rash extending from chest in front to waist behind. He was "nobody's baby."

Well, he has a father and a mother now! In fact, there's a certain school principal, with whom I had an encounter

recently over a mishandled situation, who would say he has a mother bear!

I want to issue a plea to all parents (and sometimes I need to hear it myself): *Don't abandon your load!* Your soldier's pack may mire in quicksand or be swept off by raging rivers, because no one else is holding on. Some communities have resources for helping children; courts can become their advocates. But I personally feel that a child needs at least one person, somewhere. Two people may be better, but one is better than none.

We seem to be increasingly more willing to push off parenting responsibilities than in the past. As a counselor in a high school, I see parents who throw up their hands, who leave it up to the school to monitor homework, who can't schedule a required immunization, who don't take action on what they can do.

I understand the temptation. I work, I parent four children, I fail. But somehow, *we must keep trying*. If no one is accountable, our children will suffer.

STANDING ON COMMON GROUND

Let's determine not to let our energy be drained off by majoring on the minors. The needs of our children are too great for us to spend our emotional and mental resources on defending our lifestyle decisions. Let's stand together on our common ground, recognizing God's common work in mothers who are sent to different places in different circumstances. "His grace is sufficient," we proclaim. Today we have unparalleled opportunities to believe that truth for mothering — in more varied circumstances than we can imagine.

We need to join hands, unite our resources materially, physically, and spiritually. When our family prays before a meal, we hold hands. I confess to peeking around the table during prayer. I see one face with cheek bones high, eyelids so puffy that they smile closed; his fingers and wrists are constantly drumming and he prefers to run between two places rather than walk. His single-mindedness, determination, and

knack for woodworking reflect his great-grandfather.

I see our child of adoption who meets my eye and grins at catching Mom looking around during prayer. The unknown gazes back at me. His impulsive behavior has no roots in any relative we know. We can't trace the source of the under-eye crinkle, or the skin that tans almost black, or the effervescent spirit that told his dad, "You don't need a reason to be happy. You only need a reason to be sad." His aggression keeps a soccer ball out of the goal though it means sacrificing knees, elbows, and teeth to protect the line.

Let's offer each other the right hand of fellowship. When we support each other as moms, we support each other's children. The child we help may be one we never parent, but one who bounces through our life—the child of a friend, the friend or "significant other" of one of our kids, a student, a neighbor. Maybe that child is one we will never know or meet, or one who has yet to be born. Let's unify for *all* the children.

MOM TO MOM ON SHARING COMMON GROUND

In Your Community
Check local listings of help groups in your area. Many communities have parent groups with a general or a specific focus. Attend a few meetings to find out which group feels comfortable and meets your needs.

In Your Local Church
Encourage your church to begin a monthly "Mom's Time." Resist the temptation to get speakers and draw a crowd for entertainment. Keep the agenda simple: spontaneous sharing.

At Work
At my workplace, moms have gravitated to the same lunch table. Rarely does shop talk interfere with our parent talk. Perhaps you can gather an informal group of moms to get together occasionally in and around work.

On Your Invitation
Don't be shy to ask questions of other moms. Invite an older mom you respect to join you for coffee or lunch as schedules permit. Swallow your insecurities and ask her about her children as well as your own areas of struggle: "How did that work?" "Why did you make that decision?" "What would you do?" Sort what you hear before the Lord and ask for wisdom to apply what you learn.

Help for Moms of Young Children

▼

Nicki was especially quiet at our lunch table. Conversation skipped from one topic to another . . . the paramedics called in to treat a student . . . Nancy's weekend trip . . . an upcoming training session on writing labs. Nicki distractedly pushed her salad around her plate.

"Nicki, are you okay?" Nancy asked.

"Just tired," she answered quietly.

Nicki had two children, eighteen months and four years. Each morning at 6:45 she dropped them off at a daycare center before commuting to work. She picked them up in the evening three days a week; Tuesday was her flexible night, and Friday she went straight to the grocery store. She described her husband as caring, but "oblivious when it comes to the kids."

Our lunch talk picked up again. We were all agreeing to sign up for the writing labs when Nicki suddenly laid down her fork and looked up at us.

"It's just not fair!" she exclaimed. "I have no time for myself. Nothing is discretionary—my paycheck, my weekends, my energy. I can't even buy a dry-clean-only blouse!"

We dropped the issue of writing labs.

It was time to listen to Nicki.

Our lunch table has developed expertise on a wide range of women's needs. Together, we represent thirteen children, one grandchild, two single parents, one combined family, and five dogs. We're especially good at giving each other realistic advice—such as let the leaf-raking wait another year. (If neighbors comment, tell them you're doing your spring mulching a season early.) And so we prepared to turn our wisdom and resources to Nicki's benefit.

We went down the list with Nicki. She was pleased with the daycare center; she liked teaching; her husband was an interesting person, although she felt they'd had little time to be friends since the kids had come.

On the surface, it seemed that the main problem for Nicki was sheer workload and time crunch. We explored options to reduce fatigue and suggested a schedule swap—a tested and proven method for promoting understanding that has helped companies as well as families balance responsibilities. The children's book *The Simple Prince*, by Jane Yolen (Parents' Magazine Press, 1978), presents this concept.

Nicki liked the idea. Allen would become the preschool taxi and grocery shopper. She would mow the lawn, write the checks, and finish painting the bathroom.

The transition had rocky patches. The daycare called: Jason's nappy blanket was missing, and so were the diapers. Nicki gave them Allen's work number. The lawn mower needed repairs and had to be taken to the shop. There were a lot of checks to write. But Nicki was persistent, and Allen was flexible.

After a two-week period of adjustment, the experiment began to work as Nicki's family settled into the new routine. We noticed that Nicki arrived at work less harried. She still wore machine-wash clothing, but the dark circles under her eyes were fading. (I wondered what Allen looked like.)

THE BONDING ISSUE

Then one day we watched Nicki absent-mindedly tapping her fork on her salad plate.

"What's up?" Nancy asked.

"It doesn't feel the same," Nicki replied. "It's like something's missing."

We probed for underlying issues, helping Nicki to examine the "whys" behind the "what" in her life.

"You feel that MOM is the one who should be there for the kids," I suggested. "You need being needed."

"Yeah—isn't this an important bonding time for Andrew?" Nicki responded. "My mom thinks the kids will be confused. It's hard to convince her when I'm unsure myself."

Bonding is a much-misunderstood topic, awkwardly carrying the weight of all kinds of principles on its narrow base of inadequate research. The term has become a convenient description for the mother-child relationship in our maternalistic culture, which views the mother as the primary caregiver.

But I can't find evidence in Scripture to support the importance that some in our society place on mother-child bonding. According to the Bible, a better descriptor would be parents-child attachment. In some cases, the over-emphasis on mother-child bonding has actually interfered with parents-child attachment. (Note the plural form of parent!)

Research is beginning to indicate that we would be wise to strive for a balance between mother-child bonding and parents-child attachment. Mothers give birth. Babies *and* mothers benefit from close contact and communicating. But two people contributed to this new creation, and God's plan is that both of them form attachments.

One fact continues to emerge in study after study: the quality of a mother's nurturing role with her baby is tied to the mother's feelings of satisfaction or frustration, regardless of whether she is a working mother or a domestic mother. Mothers who are highly satisfied with their roles, whether or not they work outside the home, display higher levels of warmth and acceptance than dissatisfied mothers.

The parental bonding of young children with working mothers is not harmed if there is satisfactory caregiving. We working moms are used to equating quantity with quality. It's

too much to expect us to change our mindset in a few months or even a few years.

Young mother, I understand your fears. You simply aren't with your child as many hours of the day as you want to be. But "quantity equals quality" is not a biblical principle, and the research doesn't support it. What *will* benefit your relationship with your child is your coming to peace about the reality that you're a working mom.

When the familiar threat of "someone else is raising your kids" comes up again—either from a friend or family member or the voice inside you—arm yourself internally with all the information you can collect. In the next chapter we'll look at the issue of finding the right care. Consistency and competency are important, and you can make choices to provide that while you're a working mom. You need not be the only important person in your child's life.

DE-CENTERING MOM

As Nicki continued to sort through her feelings, she discovered one of the reasons she needed to be needed. Having people depend on her stroked her ego. Playing the role of center hub to keep the family wheel rolling made her feel important. But she was paying a price for that feeling.

Nicki liked the ideal of the Supermom. In her dreamier moments, she still thought she could do it all if she could just get organized enough.

Christian working moms often add another dimension. If we could just be spiritual enough, self-sacrificing enough—with a heavy dose of organization, of course—we could be Superspiritual-mom.

What's wrong with this picture? Well, what's *not* wrong with it is pride in our children. Proverbs teaches intergenerational pride: "Children's children are a crown to the aged, and parents are the pride of their children" (17:6).

What *is* wrong with the Superspiritual-mom complex is when we cross the line and base our self-esteem on our children's accomplishments—or simply on their dependence on us.

As Nicki came to terms with this tendency in her own life, she came to peace with the new balance of parenting in her family.

Nicki and Allen eventually tailored their schedule swap to what worked best. Allen continued the morning preschool taxi route, and Nicki picked the kids up in the evening. Grocery shopping became a shared task, each taking a turn every other week with the shopping list that was taped to the refrigerator. Nicki felt relieved to give up the load of "what's in the kitchen is my responsibility."

De-centering mom has proved helpful in our family. Its usefulness has continued as our children have become teenagers. When the poignant cry sounds, "We're out of cereal!" (or dog food, or hamburger buns), the appropriate reply rings back, "Is it on the list?" The problem can be solved within a week. Staying supplied becomes a shared family project, reinforcing shared responsibility and accountability.

We began this practice for survival as a family of three. I believe the results will impact the future families that our children establish. I'm sure my teenage sons will carry the influence of watching their dad write down on the list not just his own supplies, such as razors and shaving cream, but general household items as well—simply because he noticed we needed them. They'll recall that he never left the kitchen before I did, because clean-up was a community task.

Dividing family tasks will help you as well as your family. If you try the schedule-swapping experiment, you'll experience even more changes—and that's good. You and your spouse will get a new perspective on the demands each of you carries, and you may experience some healthy changes in your marriage relationship.

ASK FOR WHAT YOU NEED— AND YOU WILL AT LEAST FEEL BETTER

Nicki realized she needed some time for herself. She didn't necessarily want to be alone, but she did need the ability to make that choice. Her one flexible evening each week sounded

ideal, but in reality she was too tired to enjoy any discretionary time on a weeknight.

Nicki and Allen decided that one afternoon each month was workable for their schedules and commitments. Now Nicki was truly able to enjoy her free time. One afternoon she read in a park; another month she biked to the lake. On occasion she spent some time with a friend.

Once in a while, Nicki found herself lapsing back into her old role as center hub in the family wheel. She would organize her family for her absence: putting the kids down for their naps, laying out snacks. Our lunch bunch was quick to point out that she was enabling her husband to be "oblivious when it comes to the kids"!

Much of parenting is learned, gender-inclusive behavior. In fact, our lunch bunch couldn't think of any gender-exclusive parenting tasks other than breastfeeding. We concluded that if a soldier could navigate field and stream with personal supplies and weapons, a dad could navigate neighborhood and grocery store with a hefty eighteen-month-old and accompanying diaper bag. The latter is just as glorious an accomplishment, in fact, although society hasn't recognized it yet.

We also concurred over lunch with the age-old truth that we learn most of the important things in life out of necessity, desperation, or both. This learning principle is also gender-inclusive. Relationships, professional pursuits, household management, or parenting—all these are information-intensive learning opportunities.

Nicki began to recognize how she sometimes denied Allen the opportunity to learn by indulging in her Supermom complex. Many of us working mothers with infants and preschoolers have learned that crisis creates new opportunities. We tenaciously cling to doing it all until our body shouts *No!* or our emotions pop the cork. Then we discover a profound truth: *somebody else can do it.*

Let's say your job entails training or coaching someone to perform a task. You would allow them the flexibility to accomplish it with their unique strengths and weaknesses. You'd give

them room to learn, not expecting them to be an expert on the first or second try.

There are parallels to parenting here. Don't communicate that dad has to do it the way mom does, or you may well provoke frustration and arguments. After all, does it really matter "who's right"? What's important is that you're a team.

Nicki discovered that her expectations for a clean home and clean kids were quite different than Allen's. Working moms who grew up in families where Mom was at home have internalized a different—if not impossible—standard for home and childcare. If your husband has those high expectations, he will learn the reality of what it takes to live up to them if he has ample opportunity to fulfill them *in your absence*.

After Nicki visited her sister alone for three days, she discovered upon her return that she was especially appreciated and understood. One of her personal benefits was a renewed perspective, which is easily lost when trapped in a survival-only schedule seven days a week.

Nicki also realized that she needed time alone with Allen, without the children. When she told Allen her feelings, she discovered that he felt the same way. For starters they had to schedule in that time—not just to get babysitters, but to make sure it didn't get lost in the shuffle as the weeks went by.

This kind of scheduling may sound rigid and unappealing to you, but the benefits will never happen unless you schedule for them. We're creatures of habit—bad habits as well as good habits. Unchecked, work will expand to consume any available time. This is true for moms of young children as well as moms of adolescents. Therefore, it's all the more important that we begin the habit as early as possible of including in our lives what is important to us by scheduling our priorities.

SHARE YOUR FEELINGS

Sometimes discussions about our needs can turn into debates. Cold nagging and hot demanding are equally unproductive. If your experience is that dialogue always ends in hurt feelings and estrangement, you may decide that the chance for change

isn't worth the attempt.

But before you give up, remember the price you're currently paying. Then *share your feelings.*

Feelings are neither right nor wrong, good nor bad. They're just your feelings. I'm encouraging you to share them, not to make judgments. This will keep the discussion from deteriorating into an argument about who's right or who's wrong. Consider the contrast in these pairs of statements:

"You don't do your share" versus "I feel overwhelmed."

"You should be more involved with the kids" versus "Sometimes I feel the burden of parenting the kids is too heavy."

"We're drifting apart" versus "I feel distant from you."

Sharing feelings instead of casting judgments reduces the impulse to assign blame. When you stop arguing over who's at fault, it's easier to listen to each other without feeling so threatened.

Verbalizing our feelings also helps us become more conscious of our responsibility for our own feelings. Although we may think that we would feel less overwhelmed if our spouse contributed more to the family, we're not in charge of his actions. We are, however, in charge of our feelings. Most husbands become a more active member of the family team as they become more aware of everyone's needs. If this doesn't happen, we must make our own chioces. We must strike off those things that are lower on the priority list so that we feel less overwhelmed.

As an example of sharing your feelings, let's assume that you feel the burden of parenting the kids has indeed become too heavy.

First, it's okay to say so. (Women may be good communicators, but sometimes we're good *indirect* communicators. We hope others will read our mind and emotions.)

Now, here's the possible conversation.

"It takes more to parent the kids than I thought," you begin. "It always seems like they're up at night just when things are hectic at work."

Good. You shared your feelings. But what if he doesn't get

your indirect message?

"Yeah, I know what you mean," he may comment. "Murphy's Law or something."

You need to be direct in your communication. He may not know when work projects are multiplying. It's okay for you to ask for specific help:

"When I'm stressed at work, will you take night duty?"

"Sure!" may be his agreeable answer. But the next step of initiative is up to you, not him.

After your next especially tiring day, ask him to take night duty. Then, when the moment arrives and your baby fusses, LIE STILL. He may take longer to notice—he may not have had as many opportunities as you to practice listening. What you do *not* do is as important as what you say.

And now a P.S.—don't forget to say thanks the next morning. You are not thanking him for getting up with the baby, because that is a shared responsibility. You're thanking him for being a team parent.

THE DISHES CAN WAIT

But you don't always have to get your husband to take over a task in order to find relief. Some things can simply be let go. Perhaps this conversation describes a familiar dilemma for you:

You remark, "I want to read to Jason at night, but by the time I get the kitchen straightened up, I'm too tired."

You're wishing he would immediately volunteer to straighten up the kitchen while you go read to Jason. But he responds:

"Honey, you'd think *Better Homes and Gardens* was coming to take photographs, the way you straighten the kitchen." Perhaps he has a point—you need to shift your perspective or priorities. So you answer:

"You know, you may be right. I think I'll just go and read. The kitchen can wait."

The kitchen *can* wait—and wait, and wait. And that's okay! When your child comes to you clutching an upside-down book and declares to you, "I read, Mommy, I read," a feeling will tug

inside you that's worth acting on right away. It's worth digging for a paper plate on Saturday morning to put bagels on because all the dishes are still waiting in the sink.

My husband and I discovered that what worked for vacation mealtimes—sandwiches and fresh fruit served on paper towels—also worked at home. We just had to give ourselves permission.

If you haven't reached the sharing stage of saying "We," the word "I" will work just fine. Say to yourself, "I give myself permission to reorder my priorities."

SURVIVAL PRIORITIES FOR SINGLE MOMS

Some moms have no choice but to use the "I" word. As our lunch group pooled ideas for Nicki, we gained new appreciation for Peg, who has been a single mom since the birth of her second child.

"He may be oblivious, but at least he's there!" Peg told Nicki. "You know that somebody else will eventually arrive home to help you pick up the pieces. I'm it."

We recalled her story about the kitchen sink plugging up. She didn't have money to call a plumber and didn't know how to fix it herself. So when her two preschoolers were splashing in the tub, in went the dirty plastic dishes along with them. While they squealed with delight, she sat on the floor and bawled.

Peg had lots of survival tips to suggest to Nicki. She'd learned how to set priorities quickly. She *knew* she couldn't do it all—she didn't have any choice. Nicki was still trying.

"In one way, I have it easier," Peg commented. "I'm no longer trying to please someone else. There's no one else to clean when my energy is gone, but there's no one else whose expectations I have to satisfy, either. This wasn't my choice, but it's reality."

I watched my sister pare down priorities as she parented her three young children alone. Frill living quickly disappeared—there was no room for extras.

When I asked my sister how I could help, she didn't want advice or groceries. She wanted me to "be there"—which in her

case mostly meant providing a safe place to leave her children occasionally when her emotional and physical resources were gone. She needed moments to herself just to make sure she was still there inside. "I don't mind how my body has changed through all this," she confided in me, "but I kind of miss my mind." She felt as if it had slipped out the back door while she was busy surviving.

Single moms, your feelings of being overwhelmed are certainly valid! I've never walked your path, but you have my compassion. I hope we can all encourage individuals, local organizations, and churches to improve the resources available to you—especially in the areas of supervision for your children, childcare support, and household and automotive repairs. In fact, as stresses on families intensify the pressure, working moms in general would like more help in childcare support. This is one of the greatest ministries a church can provide.

CARING FOR YOUR MARRIAGE

Peg gave Nicki another important piece of advice: "One of the best things you can do for your kids is enjoy their dad."

How easy it is for working moms with small children to forget that building the family starts with the foundation of the marriage relationship. When that relationship feels fragile, it's amazing how other things crumble into insignificance.

Bob and I discovered that our communication time could easily get used up with all the "stuff" of running a household with children. We had to call time out and ask each other, "How are you, really?" "How are you feeling about *us*?" The answers we've heard from each other have shifted the course of our marriage in different seasons.

We tend to forget that our jobs don't always have to pull us away from each other. They can provide a shared dimension through establishing a common link of understanding.

When Bob's first job required that he travel, I glamorized that aspect of his work. Quiet meals in restaurants. No noise, no incessant voices. No sticky fingers smearing peanut butter

and jelly on his clothes. An easy snooze on the airplane, so he could arrive home rested and eager to take me out to dinner!

Then I had my chance to live out these little daydreams when my freelance writing began opening up travel opportunities. Tight schedules. Missed meals. Endless meetings crammed into days that stretched well beyond eight hours. Noisy, crowded airports and flight delays. Follow-up notes that ruled out the luxury of naps even on smooth flights.

When I finally reached him through the crowd at the airport, I slumped into his arms. "Honey," I said, "I see why you just want to come home to a homemade bowl of chili and your own bed."

Every now and then, talk about what your working has brought to your marriage. It's okay to remind yourselves of the positives when the negatives are looming.

"How do you think my working has enhanced our marriage?" Nicki asked Allen one day. She was pleasantly surprised at his answer. As she could have predicted, he appreciated her financial contribution and her personal efforts to improve her abilities. But then he added, "I love hearing you talk about your kids at school. They're lucky to have an English teacher like you." Nicki's experiences added color to his daily routine in working with numbers.

Allen's comments didn't reduce the heap of dirty clothes, change how early the alarm clock went off, or magically restock the diapers on the changing table. But they did energize Nicki with a sense of team spirit. She felt the friendship growing again.

▼

I can see the skeptical look on your face as you ask me across my kitchen table, "But what's the big deal if I don't share my feelings that much? The days are so hectic, and lots of times my feelings come and go so quickly anyway!"

As I refill your cup, let me share two reminders. First, *you're in new territory.* It's only a recent phenomenon that moms of young children worked outside the home, separated from their kids for much of the day. You're on the leading edge of

change (but it's hard to feel special when you're so tired all the time!). Most people still don't know or don't recognize what your needs are.

And second, *your husband's in new territory too.* Becoming a parent is new turf for him. Becoming an empathic, co-partner in parenting is most likely *scary* new turf for him! He wants attachment with you and bonding with his child. But he's also climbing a learning curve. He needs to hear from you, for his own sake as well as yours.

My friend Don Cole, pastor and overseas missionary, described the role of the "dew dryer" to me from his life in Africa. "When people set out on a journey through the bush," he explained, "the dew dryer led the way. As the line of people filed through the dense brushes and tall grasses that were soaked with the morning dew, this person led the way, shaking the plants so those behind could stay dry while walking through the bush. Of course, the dew dryer finished the journey soaking wet."

Young moms, you're dew dryers, leading the way. Those who follow you will benefit from your experience. Keep talking, keep asking, keep trying. With God's grace, you're blazing a new path.

MOM TO MOM
ON SURVIVAL WITH YOUNG CHILDREN

Miriam's Household Tips

Sometimes, relief is just around the corner. Here are some suggestions for quick relief:

- ■ *Dirt will wait.* Kids are more important than cleaning. Besides, it takes the same amount of time to wash a floor that's waited for a month as a floor you washed a week ago.
- ■ *Yard leaves are biodegradable.* Pick your battles — and then don't bother fighting the ones that are unnecessary. Take your baby for a walk around the

neighborhood. Your child needs you. Nature will take care of the leaves.

■ *Priority equipment: telephone and microwave in good working order.* You need instant communication with your network—childcare, school, fellow carpoolers, babysitting co-ops. Okay, so maybe the microwave isn't a hot priority, but the more your kids eat, the more you'll depend on it. I know I'm a believer.

Attitude Adjustments

Perspective counts. Here are three attitudes I've found helpful for developing satisfaction:

■ *Be thankful you don't have time to shop.* People are more important than things. The fewer clothes, gadgets, and toys you and young children have, the less time you'll spend on upkeep. It's one way to reduce clutter!

■ *You only get one body, so take good care of it.* There's no reissue for replacement parts on request. Eventually, your kids will develop independence and attach to others. You will move on to different work. But for better or for worse, your body stays with you. Treat it right or it'll start making demands on you that you can't ignore.

■ *Keep an open mind by sorting through what you hear.* Ignorance is bliss until it trips you up. Accurate information is invaluable. Listen critically to others; be thoughtful in learning from their experience. Consider where they're coming from before you internalize their message.

Use Your Support Resources

Don't try to go it alone. You need support, and with a little effort you can find it. I recommend:

■ *Get the best caregiver you can find.* The early years *are* important. Caregivers will strongly influence your

child. Research, ask for referrals, interview, pray for guidance. Then make your decision carefully — preferably as a team decision with your husband, if possible.

■ *Connect with other parents.* A close network of parents can become a vital team in handling survival issues — from carpooling to information resources to emergency aid. But another reason to get to know other parents is so you know something about who is influencing your child's peers.

■ *Pray.* Your greatest resource is free, and available at any hour from any location. Don't let guilt over your shrinking time with God keep you from coming to Him with your needs. God specifically tells us that when it comes to prayer, quantity does not mean quality. Any short prayer — such as "Help!" or "I love You, Lord" — is acceptable.

Choosing the Right Care for Your Kids

▼

H ave you ever experienced that startling moment of wonder and reflection when you looked at your child as if for the first time all over again and thought to yourself, *Who is this little person who has irreversibly changed my experience of life, the minutes of my day, my future plans, and maybe even my underlying values and convictions?*

I think this question breaks the surface when we begin to grasp on a very elemental level that however dependent our children may be on us, they have an existence independent of us — the mystery of their own emerging personhood. Our lives will always be inextricably intertwined, yet we will always be separate, unique individuals. We will constantly be prompting each other to ask the questions, "Who am I? Who are you? Who are we in relation to each other?"

These are important questions, which most of us continue to work through in one form or another all of our lives.

But I think it's especially helpful to working moms to ask them very specifically in order to look more closely at who our children are, how they relate to us, and how we relate to them. The better we know our children as the unique individuals they

are, the better able we'll be to make wise decisions about their care, about what we can compromise, and about what we are and are not willing to sacrifice.

We don't live idyllic lives in quiet cottages with roses climbing pristine fences and the sun shining every day. We live in real worlds. I'm sure you already know some of the pangs of compromise, the quiet resignation of releasing expectations, perhaps also the pain of sacrifice.

But that doesn't mean that we just have to grit our teeth and get used to grim reality. We can learn how to minimize the disadvantages of our work for our children and maximize the benefits. (And I believe there are benefits!) Because we work, our parenting will be different. We can make choices based on our children's needs, not on our need to assuage our guilt. But it starts with understanding who our children are.

KNOWING YOUR KIDS

"Children are wet cement," it's been said. "Adolescents are the product of their environment." We hear many messages these days that come down heavily on one side of the nature-nurture debate. I studied B. F. Skinner in my psychology classes and was informed that children are blank slates. (Now you know how old I am.) Stimulus . . . response . . . reinforcement. Our era has been proclaiming that kids are what we make them.

But there's a different message coming from a less formal level of observation—parents and grandparents. They maintain that newborns already have their own personalities. "Different from the day he was born." "Like night and day—sisters in name only." Some of us have known all along that this is true. Not because we discovered it, but because God created people that way.

Psalm 139 tells us that each of us was fearfully and won-derfully made, that before our bodies had formed in the womb, God knew each day of our lives. Romans 12 tells us that each of us has different gifts. Proverbs 22:6 affirms an inherent indi-viduality for each child—"Train up a child in the way he should go; and when he is old, he will not depart from it." Nurture, or

"training," is important—but equally important is the "way he should go." The Hebrew meaning refers to a particular personality bent. God created us each uniquely and has unique plans for how our individual lives can glorify Him.

As an educator, I have found it interesting to see a growing body of research in alignment with the teaching of Scripture. Stella Chess and Alexander Thomas, professors of psychiatry at New York University Medical Center, have compiled an impressive body of research showing that people are different from birth.[1] Their findings provide helpful information about differences in children and how those differences impact families and parenting.

I believe this research has practical value for your day-to-day challenges. But I also feel strongly that it can help free you from the false assumption currently circulating that working moms are the cause of their children's problems. If you have internalized this assumption, you need this information to counter that message in your own heart and to share this information with those who are sending it. The adult your child becomes is not solely the product of a working mom.

In 1956, Chess and Thomas began a longitudinal study of 133 infants. They gathered extensive information about behavior from birth in eating, sleeping, activity level, and acceptance of new foods. They followed these infants through preschool, middle school, adolescence, young adulthood, and are currently continuing research with the subjects in their early thirties.

The researchers drew an early conclusion that babies are different from the start. Some were easily distracted during feeding; some cried softly, some loudly; some lay quietly, others moved continually. Their conclusion: infants were competent human beings at their own infant level of abilities and activities. These differences were referred to as temperaments, or the "how" of behavior.

Think about the temperament of your child when he or she was an infant. Mom, you may be able to describe much of your infant's behavior with little effort. Even dads who have

been less involved in their children's daily routines can often describe their children's temperament fairly accurately.

Chess and Thomas established nine categories of temperament on which they rated the infants:

1. activity level,
2. rhythmicity (predictability or unpredictability),
3. approach or withdrawal (initial response to a new situation),
4. adaptability,
5. sensory threshhold (level of stimulation necessary to evoke a response),
6. quality of mood (pleasant or unpleasant),
7. intensity of reactions (energy level of response),
8. distractibility, and
9. persistence and attention span.

The ratings on these nine categories were then summarized in three temperament-related patterns of behavior: the *easy child*, the *difficult child*, and the *slow-to-warm-up child*.

The *easy child* has regular biological functions, a positive approach to most new situations and people, easy adaptability to change, and a mild or moderately-intense mood that is mostly positive. This child is a joy to her parents, teachers, and most of the outside world. Forty percent of the infants in the study were in this group.

The *difficult child* is at the opposite end of the temperamental spectrum. Body functions are irregular, new situations typically provoke negative withdrawal reactions, adaptability to change is slow, and intense mood expressions are frequently negative. Crying is frequent and loud; laughter is loud; frustration will likely produce a tantrum. Parents, pediatricians, nurses, and teachers find these youngsters difficult to handle. Ten percent of the sample were in this group.

If you're thinking in desperation, "That's my kid!" then pay careful attention to the researchers' comments on this group:

It should also be emphasized that parents do not produce this temperamental pattern in a child, although the way parents respond to such a child may minimize or exaggerate the difficult features of the child's behavior. Given sufficient time and patient handling, these difficult children do adapt well, especially if the people and places in their world remain constant.[2]

The *slow-to-warm-up child* responds negatively to new situations and people and adapts slowly. However, in contrast to the difficult child, this child displays mild rather than intense reactions. Rather than throwing a tantrum, he will typically withdraw from a frustrating situation. The slow-to-warm-up child can be called shy as long as the term does not imply anxiety or timidity. Fifteen percent of the study were in this group.

Not all children fit neatly into one of these three groups. Some have varied characteristics, but categories help us look at general patterns of difference. Temperament is one important factor, although of course not the only one, in shaping personality.

Interestingly, Chess and Thomas found temperament to be consistent over time. They acknowledged that many factors shaped the developmental course—such as intellectual competence, social patterns, adaptive mechanisms, and value systems—but there was dramatic consistency in one or more attributes over time.

My limited experience as a parent confirms this. Our eldest, who had to sleep with a net over her crib from nine to eighteen months because of adventurous roaming during the night, graduated from high school a year early in order to go off to college in another state. Our second child, the sleeper, never needed to be in a playpen: he played at my feet or anywhere I placed him. Now a teenager, he is a homebody, a couch potato in a delightfully peaceful way—content to be near pizza and sound equipment.

I remember Grandma describing my mother: "She'd sit for

hours playing with a string. Hold it high over her head, she would—then she'd drop it, and study the designs she made."

Then she exclaimed, eyes twinkling, "Now your Uncle Reid—that's another story. Set him down and he was off on a tear!"

As a counselor and mother, I've drawn four guidelines from this study that I believe are especially important for working mothers—all mothers, in fact. We sometimes search in frustration for the "why" of behavior when the "how"— meaning temperament—is more important to understand. Consider these suggestions as you reflect on your child's behavior:

Don't assume that if your child behaves differently from what you expected and hoped you've been a "bad" parent. Your child's temperament may differ from your perceived norm even if you are a perfectly adequate parent.

When your child is behaving in a way that upsets you, don't assume that it's deliberate. The child who forgets to call you after school may also forget to be on the ball field.

Don't make moralistic judgments about your child because of behavior that doesn't live up to a rigid standard you have set. One father of a temperamentally difficult girl in the study labeled her "a rotten kid" because she didn't adapt quickly to successive new rules and regulations of social living that were demanded of her.

Another parent condemned his easily distracted son, who also had a short attention span, as lacking willpower, because the boy couldn't sit still for several hours at a time to go through his homework from start to finish. The boy was actually bright and did well in school. But his study habits were different from his dad's.

Don't ascribe all difficulties you experience as a parent to the fact that you are working.

If we consider this information and pay close attention to what we know of our children from birth on, listening to what they tell us about themselves, we'll be better able to discern the "way they should go." We'll understand that the uniqueness

we see in each of them is no accident of circumstance; those differences are God-given.

KNOWING YOURSELF
IN RELATION TO YOUR CHILD

I've pictured the family as a hammock: Mom and Dad facing each other holding the hammock, the child or children safe within certain boundaries. Some families are Mom, Dad, or some other adult holding both sides alone, but the hammock image loosely describes this institution called family.

Let's look for a moment at the hammock holders. Just as each child was uniquely created, so were we. We have different temperaments, which have evolved into personalities. And whether we're compatible with our children or not, we're part of a team with them. God has given us the assignment of training. So besides knowing our child, we need to know ourselves.

The parent we've become is a product of our temperament, the role models provided by significant others, our environment, and a host of other factors. We were once unique children, who became adolescents, who became mothers. Some mothers are secure, others are insecure; some intimidated, others overbearing. These characteristics may or may not be true in other areas of our lives. A secure businesswoman may be an insecure mother. A secure mother may be an insecure public speaker. Think about your temperament for a moment. How does your temperament affect your mothering?

Some parental styles make a significant difference with some children and not others. A home full of tension is not a pleasant environment for either parent or child. Chess and Thomas propose this thesis: a child's psychological development is not determined by the parent's style alone, or by the child's style alone, but by *the match or mismatch between the two.* They call this "goodness of fit."[3]

Think of someone who grates on your nerves. That's what "goodness of fit" is *not*. When two people match each other in fundamental areas of common ground, or are able to accommodate each other's differences comfortably, goodness of fit

describes the relationship. Like a comfortable pair of running shoes or your favorite old clothes, it feels right.

Goodness versus poorness of fit between family members is extremely important. I frequently observe this concept in operation from my office.

"I hate her," Jean said with shaking voice. "She's my dad's favorite. They never fight with her. She's never grounded."

Jean was a "challenging" student. She continually challenged teachers; she was inconsistent, emotional, and unpredictable. She was either madly in love or dumping some creep who might have been the person she was planning to marry yesterday. But Jean's younger sister was easygoing, calm, everybody's friend, a challenge neither to teachers nor to her parents.

These sisters were raised in the same environment, yet each experienced a different environment due to goodness of fit. Jean did not experience this sense of rightness with either parent, while her younger sister did.

The following formulas are oversimplified for the purpose of illustration, but they provide a helpful snapshot of how goodness of fit (or lack of it) affects family environment:

- Calm child + calm parent = heaven in the home.
- Calm child + hyper parent = balance.
- Hyper child + calm parent = balance.
- Hyper child + hyper parent = heaven help the fireworks.

Have you identified the combination that describes you and your child? We can parent more effectively when we recognize our differences and can predict possible difficulties. Most of us have multiple combinations in one home. As I look at this model, it helps me understand within our own family why I have different relationships with different children, and differences when compared to my husband's parent/child relationships.

Our youngest son, Rob, is one of those young men with boundless energy, which equals endless activity as well as

speech. I wear down and my patience evaporates.

I'm more comfortable sitting with my couch-potato son John and my cup of coffee watching the birds at the feeder outside our window. Rob flies by the window on the tractor mower. He mows the patch under the birdfeeder three times, approaching from different directions, always at high speed.

Then Dad goes by with the hedger. He and Rob take off for the hardware store to get supplies for the next project. Then Charles joins the crew and they build a skateboard ramp. After dark they're still hammering, and when they're done hammering they're still talking—about the *next* project. John and I make plans to go to a used-car auction on our next free day. It's too hectic at home. We might get put to work!

PUTTING YOUR KNOWLEDGE TO GOOD USE

The concept of goodness of fit has implications for working mothers. When deciding alternatives for childcare, we need to know our child. A daycare center may be suitable for one child's temperament but not for another's.

One couple's infant son had digestive difficulties and adapted slowly and with difficulty to new people. In this case Dad chose work offering flexible hours to accommodate little Nathan, who needed a consistent caregiver. By knowing their child, this family made wise choices for his care.

Ideally, as a working mom you need not make decisions alone regarding care. But whether you're a single working mom or making decisions with the help of Dad, knowing your child's temperament and needs is a priority.

We may be *absent* moms—not present with our child during those working hours—but we are not *absentee* moms. We parent in our absence through our chosen nurturing caregivers. We parent through the location we've chosen and the influences of the number and other types of children in that location. We parent through our interaction with those caregivers.

My friend Sandy Dillon has been a working mom for many years, and she communicates well with her adolescent children. When I quizzed her about how she gained her exper-

tise, I learned that the seeds of their family relationships had been sown in her children's early years. While maintaining a challenging career and volunteering at her church, she has made it a priority to tune in to the unique needs of her three children.

Sandy actively looked for caregivers who could complement her personal strengths. She is a thinking organizer, but she does not have strong artistic skills and creativity. So when her children were small, she chose a caregiver who baked, colored, and canned vegetables with her children.

When working moms are sensitive to goodness of fit, a child's sense of security increases. Sandy's daughter was talkative and outgoing as a preschooler. When she entered kindergarten, something changed. Sandy learned at a school conference that Christina had not said a word in three weeks. This working mom arranged her schedule to invite Christina's teacher home for lunch. After that experience of three for lunch, Christina became her usual articulate communicator at school as well as at home. Sandy knew her child.

Goodness of fit does not mean absence of stress for a child. Some tension always accompanies change for children as well as adults. Expectations increase as a child becomes increasingly competent in social skills and tasks of living. It isn't helpful to try to shield a child from these naturally-occurring stresses.

For example, imagine a shy child whose parents allow him to stay home from school when difficult challenges arise, justifying their decision by excusing him as ill at ease in new situations. This child may continue to lack the confidence necessary to face new tasks. Eventually his self-esteem may flounder, or in extreme cases a school phobia may develop. The parents have not helped their child by trying to protect him from this kind of stress in his life.

Sometimes, however, unnecessary stresses are forced on children where goodness of fit is lacking. The research related to goodness of fit has revealed that generation gaps occurred in families where parental demands and expectations were excessively stressful (poorness of fit), resulting in behavior problems

in the children. In these cases, the parent-child relationship was usually either cold and distant or openly antagonistic. However, this alienation of parent and child almost always started in childhood — even early childhood.

I wish I had started documenting years ago how teens in my office described relationships with their parents. In my experience, adolescents who are communicating reasonably well, who seem to have a good relationship with their parents (and there are many of them), report that things have not changed. They have "gotten along" at home most of the time while growing up. Likewise, adolescents who are in constant conflict have experienced difficulty, or at least minimal communication, as a longstanding pattern.

A significant factor changing this scenario is the change in the family. Let's look at how divorce relates to goodness of fit, because most children don't live with both biological parents. For those of you who have experienced divorce and/or are stepparenting, this is important. You may believe that your work caused fireworks, or at least difficulties, which in fact were due to other causes.

A child who began life with goodness of fit, or at least reasonable balance, experiences a radical new dimension with divorce. Mom or Dad goes through such a change in environment and emotions that the fit changes. Then a new parent may come on the scene, which may or may not achieve a balance.

The effect of divorce on a child can be minimized if the biological parents can continue to co-parent their offspring consistently, without making the child a pawn or battleground. Though important for all ages, this is especially true for adolescents. That hollow space that can be filled only with a positive self-image may get larger and more fragile for a few years. In order to spring into independent adulthood, teens need an especially stable, yet flexible, family board from which to bounce.

Divorce shakes the family springboard. By some estimates, nearly half of all children in the custody of their mothers have little or no contact with their fathers. Another sad but true fact is that when finances are a problem and the child's level of

living is significantly affected, he experiences greater problems following the divorce. In other words, money *does* matter. Upon divorce, a woman's standard of living typically drops 73 percent; the man's jumps 42 percent. Though security cannot be purchased, poverty extracts a price. One third of working women are single, divorced mothers whose income drops them below poverty level.

Adolescents perhaps feel this more than younger children. We may wish otherwise, but adolescents *are* affected by what they can wear: peer status is frequently established by material possessions. They also adapt more slowly than younger siblings if a home and school move become necessary, as is frequently the case.

A mother going through divorce called me and asked me to talk to her daughter. Usually quiet and respectful, Leah was becoming argumentative to the point of throwing punches at her older sister and adding turmoil to an already precarious household environment. Mom and three daughters had many problems to face, and Mom wanted help.

Leah quietly entered my office alone, folded her 5'10" slender body onto a chair crosslegged, and looked at me skeptically. I told her what her mom was asking of me, explained that I had only heard one side of the story, and said that I wanted to know how she was doing in the turmoil.

Leah was not doing well. She described a perspective that she couldn't express to her mother.

"I look like my dad. I act like my dad. We got along; Mom and I never did. But we didn't have to—now we do. I think she hates me."

She described a family in which she had experienced goodness of fit with her father. Her sisters related better to their mother. The family maintained balance until Dad left. Balance had turned into "heaven help the fireworks."

Though divorcing parents have many issues to face and compromises to make, they will help their children by considering goodness of fit in how they will co-parent after the divorce. If they don't take this into consideration, the child,

especially during adolescence, may force them to communicate by creating a crisis.

Leah's mother cared for her and was open to listening to a few of my gently expressed concerns. An objective outsider—whether school counselor or significant other—brings no family baggage and can be heard a bit better than a teen during some periods.

I later saw this mother and daughter communicate with more understanding than perhaps they might have experienced if the original family had stayed intact. I'm not suggesting that there were more positives than negatives in the divorce. I don't know the whole situation. But this mother and daughter made the best of a trying time period and established their own goodness of fit.

Are you a working mother going through divorce or living in its aftermath? Your wildly swaying hammock *will* settle down. I can't tell you that if you must hold both sides of the hammock, it won't be heavy. But I can tell you that the fireworks are likely to be temporary, and that in time you will establish a new fit.

Growing up today isn't easy, whether mom works or not. Families don't experience goodness of fit just because Mom is home all day. I fear that as working moms we're too quick to take on responsibility for all glitches and problems. We've internalized the lopsided view that everything about child development, behavior, and care belongs squarely and solely on mom's shoulders. And if we haven't blamed our work for the problems, there are many institutions and individuals who have.

Children are different; moms are different; dads are different. What happens in development and relationships on a daily basis is greatly influenced by variations in how the hammock is held and who's holding it. Goodness of fit is a more important characteristic than we have acknowledged in the past.

When we work, we must depend on other caregivers for our children. In a sense, we're extending our family—but we're picking the "extensions." A workable, positive caregiving

situation may be beneficial for one type of child and not for another. The better we come to know our own child, the better selection we make in caregivers—perhaps avoiding changes required when a good fit is lacking.

CHOOSING CARE
THAT MEETS YOUR CHILD'S NEEDS

In 1989, twenty authorities prepared a consensus statement on children's developmental needs. Edward Zigler, director of the Bush Center in Child Development and Social Policy at Yale University, summarized it as a combination of good news and bad news: "What we essentially reported was that the developing child needs environmental nutrients—affection, attention, care. If the child receives them at home, he or she will develop optimally. If the child receives them outside, he or she will develop optimally. If the care is of really good quality, there's not much to worry about."

The bad news was made public in October 1989, in what Zigler calls "the most important child care study of the decade," the National Day Care Staffing Study. Unfortunately, they discovered that the quality of care for many infants and older preschoolers can only be described as "very poor."[4]

Factors contributing to poor quality include a staff turnover rate of 41 percent annually. Infants and children identify with and become attached to their primary caregivers, and it takes time to establish fit. Children thrive on consistent care. Those who have to relate to an everchanging stream of caregivers spend more time in aimless wandering than those at centers with more stable teaching staffs. In addition, they don't interact with each other as much, and they don't learn words as quickly.

Another contributing factor to poor quality care is near-poverty-level wages, averaging $9,363 annually for a full-time worker. Average pay is 27 percent less than in 1977. As a result, workers are quitting their jobs at nearly three times the rate of a decade ago. In 1977 the average center had to replace 15 percent of its staff each year; today it is 44 percent. The study

found that salaries are a strong indication of how good a center is. The highest pay for a teacher at an average childcare center in Illinois is $10,500, which may explain why staff exit when better employment options become available.

An interesting finding in this study was that nonprofit and church centers pay higher wages than for-profit centers, and provide better quality care.[5]

Armed with this information, working moms — and dads — can search for care for their children with more tools to make a wise selection. Miriam Adeney's book *A Time for Risking* provides excellent help for making this decision.

Choosing good childcare is one of the most important and difficult tasks facing parents today, and most parents feel ill-equipped for the search. You may be one of those fortunate mothers who has an available and willing relative who can help you. Ten years ago this was a more common solution than it is today. Why? Grandma and Aunt Nellie are more likely today to have jobs themselves or be living far away.

Consider the following five guidelines when looking for daycare for your child.

1. *Allow yourself time.* You're not looking for a repairman for your car. Your child is irreplaceable.

2. *Focus on who rather than what.* The woman or man who will be taking care of your child is more important than the form or structure—nannies, daycare homes, childcare centers—of the arrangement.

3. *Spend time observing before you make your decision.* The best and only way to know about that person is to watch her. Spend at least half an hour, preferably half a day, observing the potential caregiver. Look at the children's faces. Are they busy? Do they look happy? What happens when something goes wrong, which will inevitably happen? How is it handled? Does the teacher get down on the child's level? Picture how you would feel if you were there nine or ten hours a day.

4. *Find out the turnover rate.* Ask what the rate of turnover is for teachers and aides. Find out how much they're paid. These are indicators of the quality of care.

5. *Once you've made the decision, stay involved.* Keep communication open and frequent. Your child can't express all that occurs. Monitor, ask, observe. Establish a positive working relationship with the staff. The hours of your child's days are dependent on it.

As parents we tend to focus on one color in the kaleidoscope of our child's environment—a light, pale, slow-to-warm-up child; a vibrant, bright, outgoing child; a dark, obscure, difficult child. We are part of that kaleidoscope, and without realizing it we can change the balance and create new combinations. When we accept and appreciate that our child is different, we encourage goodness of fit. The caregivers we select are part of the kaleidoscope. There are myriads of combinations and many ways to achieve balance.

HOW YOUR WORK BENEFITS YOUR CHILD
When we know our kids and ourselves and put that knowledge to work in choosing the right care for them, the fact of our working can have several positive benefits in our kids' lives.

Basic Survival
The benefit of basic survival may seem obvious, especially if you're a single parent. But I include it because many people continue to think, despite the statistics, that mothers work for luxury items and materialistic ambition. Two-thirds work due to need. They are divorced, separated, never married, or married to husbands whose incomes are less than $15,000 a year. Many children in our nation have bread on the table, a roof over their head, at least some medical care, and the opportunity to learn because their mothers work.

Observation of Women
Exercising Diverse Abilities
Daughters' aspirations are influenced by what they observe. They may choose to have children and work in their homes, which is a wonderful choice. My daughter, Valerie, may make that choice. Realistically, however, given the statistics on family

stability and projections about our national economy, she will probably not have the freedom to choose that path exclusively or permanently. But her choices will be more thoughtful because she observed a diversity of role models among working women.

Involvement with Dad
It's difficult for me not to get up on a soapbox on this issue. It's vital for our children to relate to their dads. Biblical examples show dads who are much more involved than in most families today. By default or by necessity, moms entering the marketplace force dads into more activity, and a more intimate relationship with their kids. Great!

Some working moms not only say, "great," but also "finally," while heaving a sigh of relief. A friend whose husband is a pastor feels she gave her three children a priceless gift by being at work in the summer. Her children went places she would not have taken them, ate things she never would have fed them, and more importantly, knew a man they would never have known had she been at home.

Accessing Resources
I mentioned earlier that medical and dental benefits may be accessible because Mom works. In addition to braces and crutches, business benefits from Mom's employer may add college tuition and counseling services—otherwise prohibitively expensive for most families.

Acquiring Life Skills
When Mom does it all at home, nobody else has to. But Mom working has kids washing dishes, sorting their laundry, learning to operate stoves and microwaves, cleaning and maintaining, and many more responsibilities. In our house, if you eat, you shop. If it's someone else's turn to shop, you write down what you need purchased. Monotonous? Sometimes. Will it help raise my kids' ACT scores? Probably not. But these life skills will come in handy.

A Surviving Mom

I include this with great fear that I will be misunderstood, but I must speak for those mothers who need a season of working outside the home in order to maintain stability in their role inside the home.

Periods of crisis or intense fireworks can sometimes threaten our emotional or mental survival. A stay-at-home mom shared with me that for one short period she had to get out and get a job because of the extreme difficulties her family was going through. Their daughter, who today is a successful bank executive and able to enjoy a full life, had been experiencing great turmoil and fear, requiring hospitalization. This mother feels that taking a job improved the family scenario and helped her survive. She now ministers to many young families, with increased understanding of family difficulties.

New Information and Experiences

Children can learn new information and enjoy an expanded range of experiences because of their mom's work. They may learn more about areas of the marketplace or have opportunities to travel. They may hear of different kinds of families and events. They may learn how to conduct a job search more than once. Moms frequently bring home a sense of achievement. These factors can add valuable dimensions to children's lives.

▼

Know your child. Acting on this simple statement takes a lifetime. Do it in connection with other parents, who can help you learn that the changes your child experiences are not all that out of the ordinary. Go against the isolation that characterizes so much of family life today, and join other moms and dads on this exciting, forever adventure.

At work I often eat lunch with Betty, a friend who parented her seven children alone following her divorce. She helped me with my perspective a few years ago.

"How was your weekend?" she asked. She knew my husband and I had planned an overnight getaway.

"Well, let me tell you." And I began my tale of woe.

We were to arrive home Sunday afternoon in time to hear our son's junior high band concert in the local gymnasium. Returning to town a little early, we stopped by home to check on Grandpa and the other three.

"Great!" was Valerie's evaluation of the weekend as she was scurrying out the door. "We [meaning her seven friends, including boyfriend] missed the bus home from Woodfield yesterday. But we took a cab. [Woodfield is a shopping mall fifteen miles away! $$$!] We'd already spent most of our money, but it turned out okay—Grandpa was so nice. He paid for the cab."

Walking through the hallway into the dining room was an unnerving experience. All the kitchen furniture was piled in the dining room, and the good silver and crystal were on the table (clean, I might add). Grandpa explained that he had let Valerie and her friends order pizza, and they'd all had a fancy candlelight dinner. Such nice young people they were. Oh yes, the kitchen floor got a bit dirty, something spilled. But Valerie had mopped it all up this morning. Things just need to be put back in order.

Nothing major. Better hurry to the band concert. Maybe it had *not* been such a good idea after all to stop by the house. We were losing our relaxed, vacation spirit.

Sitting in the bleachers, we watched for the trombone section filing into the gym. Where was John? There was a boy about his size who looked like him, but instead of John's sandy-brown hair he had white-blond hair. The boy looked up at us and smiled. Braces and all—that *was* John! We pointed to our heads and gestured wildly. Because there were several hundred parents between John and us, we could not yell, *"What happened to your hair?!"*

We were later told that John had agreed to the project, although the vow of silence remains unbroken regarding whose idea it was. The story goes that Grandpa was dozing through the end of a Chicago Bulls basketball game on television. It was around midnight. There wasn't much to do, so Valerie dyed John's hair.

In conclusion, Bob and I decided maybe leaving town hadn't been worth it, and the children decided Grandpa was the greatest: loving, generous, and the kind of grandpa everybody should have.

I ended my tale at the lunch table and looked at Betty for sympathy.

"Were the police called?" she asked dryly.

"No," I responded.

"Then don't complain," she said.

▼

Perspective. This invaluable parenting tool is not delivered with the birth of the baby. We acquire it in communication with other parents.

I am learning that my children are different not because I work, but because they were created to be unique. Whether my family experiences goodness of fit is not determined by whether I work outside our home. It's determined by children's temperaments, parents' temperaments, who's holding the hammock, and who's in the hammock. Goodness of fit is determined by how we accommodate and respond to our differences.

We direct these differences positively by knowing our child and making choices to promote goodness of fit in the caregivers we choose to hold the hammock in our absence. The colors of the kaleidoscope will change—but different can be good.

MOM TO MOM ON KNOWING OUR CHILDREN

You're Not the Source of All Problems

Dear working mom, you are *not* the cause of all family problems. Keep yourself from internalizing false guilt with these thoughts:

- *Rest assured that the fact of your working did not and does not create your child's personality type.* Goodness of fit is not dependent on whether you work or stay at home.
- *Your child most likely benefits from enriching experiences because of your work.* The next time you pour yourself a

cup of coffee or tea, think of ways your work has provided positive stimulation for your child.

Listen and Learn
Goodness of fit celebrates differences—it does not require a cookie cutter to stamp parents and children into proper shape for prescribed results. Listen to others and learn from their ideas—but remember, you and your child are unique!

If you want a stimulating conversation some day, sit down with a mom who has a challenging child and ask her to tell you how their unique relationship is growing. Chances are good you'll learn more about knowing children as unique individuals.

Evaluating Goodness of Fit
If you want a handy exercise for digging into your family's goodness of fit, sit down with a notepad and work through these four areas:

1. Briefly describe each member of your family according to the following tendencies:

- activity level: overdrive, neutral, or needs fuel.
- people person versus loner.
- user, free taker, or giver.
- contemplative versus jumps to assumptions.
- outgoing versus quiet.
- likes cold versus likes heat.
- readily happy versus readily sad.
- talker versus listener.

2. Describe the goodness of fit between each possible pair in your family. Where are the areas of common ground? Where are the areas of clashes?

3. What impact does your working have on goodness of fit between each possible pair in your family? Is it positive or negative?

4. What reasonable compromises could you make to help develop and strengthen goodness of fit in your family?

How to Really Love Your Teenager

▼

Before I became a mother, I remember thinking that it would be easy to keep pace with my career when my yet-to-be-born children became teenagers. They wouldn't need as much parenting then.

Dreams.

Listening to media today, we might assume that the presence of a teen dooms a family to the "heaven help the fireworks" category. We are confronted with news about the increase in teen suicides, drug use, and promiscuity. So it looks like we're just going to have to brace for what's coming—plug our ears, put on our hip boots, and wade into the worst period of our life.

For working moms who are already overtaxed, this is extremely bad news.

Constant fireworks are not necessarily standard issue for a house with teens—though I would hasten to add that parenting adolescents is not easy for moms at home *or* moms in the marketplace.

Yet we hear from Christian leaders such as Chuck Swindoll, whose four children are now adults, that the teen years were

some of the happiest years of their family life. Dr. James Dobson, in *Parenting Isn't for Cowards* (Word Books, 1987), refers to adolescence as a turbulent part of the stream in the river of life, a time when the adolescent canoe may bounce, but few are wrecked. Generally the waters smooth out, and some even glide through with very little white water.

UNDERSTANDING TODAY'S TEENS
Dobson's research indicated that about 20 percent of adolescents were emotionally disturbed to a meaningful degree. Within this 20 percent, he distinguished between those who were quietly disturbed—had not been seen by a mental health professional more than once, had never been arrested, had never been involved with the courts, had never been held in a detention center, had never run away from home, and had never abused drugs or alcohol—and those who were actively disturbed, meaning they had experienced some of the above.

The gender distribution was striking. Among emotionally disturbed adolescents, the majority of males, 65 percent, were actively disturbed; 35 percent were quietly disturbed. For females, the percentages were reversed. Remember, however, that for every adolescent who was disturbed, four were not. This study concluded that the vast majority of adolescents were happy and well-adjusted.

Not all studies agree. One contradicting piece of information asserts that 40 percent of all teenage girls are pregnant at some time. This tumultuous event, regardless of whether it results in birth, abortion, or spontaneous miscarriage, swamps the girl's canoe as well as her family's. Parents without a self-professed Christian perpective often experience guilt for their apparent failure to establish their daughter on a positive course through life. Christian parents may carry the weight of additional burdens by hiding their feelings or laboring under the judgment that they failed spiritually because they apparently did not teach moral values successfully. Pregnancy brings fear, fireworks, disillusionment, and despair.

But these situations, tragic as they are, do not paint the

whole picture. As a counselor, I spend perhaps a dispropor-tionate amount of my time with adolescents who are disturbed or in temporary conflict. But many teens are relatively happy, relatively successful, and paddling their canoes with reason-able competence.

How we understand today's teens has a lot to do with how we choose to understand the developmental stage of adoles-cence. It's a kind of self-fulfilling prophecy. If we view ado-lescence as a period of turmoil, rebelliousness toward family and society, and an inevitably widening generation gap, our expectations will probably be realized in the lives of our teens. On the other hand, if we choose to see adolescence as a period of developing independence and resilience for jumping from the springboard of family into adult living, these expectations will probably become reality in the lives of our teens. If we antici-pate goodness of fit to the greatest degree possible to cement a friendship for a lifetime with a unique and interesting person, we will most likely experience that happy eventuality.

The fact that I work with and parent teens doesn't make me an expert. But I will try to help you by describing what I see in the world of adolescents. We all need to look more closely at their world, because it's a radically different world than most of us spent our teen years in. As we explore the environment they live in, we'll discover their unique needs—which moms in the marketplace as well as moms at home need to be aware of. And then we'll look at what working moms can do in order to really love their teens.

KIDS NEED TO BELONG

If I could take you for a walk down the school corridor where I work, you would see a mixed parade of teens—preps, punks, jocks, and nerds intermingling in the rush to get to class on time.

Though the groups differ from each other, within each there is great conformity. One group wears mainly black. Another signs their identity in pale jeans, deck shoes, turtle-necks, and sweaters. Still another flaunts anything that is the

opposite of what all the other groups do. Orange or green is the haircolor of choice; hairstyle is spiked or shaved; crosses, bangles, leather, old, and large are in.

Looking down the hallway, it appears that adolescents are willing to be different. But follow them into the cafeteria. They divide neatly into their own groups to which they conform, from dangling earrings to combat boots.

Adolescents want to belong. They want to believe they're independent, yet they go to great effort and expense to conform to the group they're in or trying to get into.

One young man sat in my office with a new look, his long hair teased out to appear unkempt, a cap on backwards and pulled down near the nape of his neck.

"New hairstyle?" I said.

"Took me forty-five minutes to fix it," he boasted.

With all their effort to look like the group, with all their fear of being singled out as different from the crowd, each adolescent *is* unique and wants someone to recognize that.

Does this sound confusing to you? Imagine how it feels to them! They're reading from conflicting scripts:

"Be like the group." *But is this group really me?*

"I want to be myself." *Who am I, anyway?*

"I want to be different enough today that someone will notice me." *But what if I'm too different, if too many people notice, or if someone laughs at me?*

Kids may be conformers at school, the mall, or the concert stadium, but they want to be accepted at home as a unique person. They want their parents to accept them for who they are, different from anyone else—different especially from any other adult, including their parents.

You may know your teen well and talk openly about most aspects of his or her life. This is not the case for many kids. I'm going to share some examples of conversations in my office, especially those with students who felt they were not being heard at home. If you and your teen enjoy regular, healthy communication in your home, you might gain understanding of your teen's friends and peers as you read the next few pages.

TALKS WITH TEENS

"I just *have* to talk to someone." Stacey pushed her bulging satchel under the chair in my office.

"I'm afraid to go home tonight. She hates me. She can't stand me! And Frank [she couldn't bring herself to call him Dad] will just walk out."

She poured out her story. She had lived on both coasts, had been shipped from one parent to another. Her California parent was jailed, so she moved in with a friend until the court shipped her to her father. Dad, meanwhile, had a new housemate who didn't like teenage girls. Stacey didn't feel safe leaving her things at home. She carried on her back a change of clothing, her toothbrush, a mirror, two cans of hairspray, her school books, a camera that she proudly declared was her favorite possession, and a letter from her little sister.

I listened.

Stacey's dad thought she didn't like him. Actually, Stacey was afraid of his girlfriend. Stacy thought her dad didn't care about her. He just didn't know how to cope with conflict, so he avoided those situations in any way he could. They needed an objective third party to help them hear each other.

▼

Most of my listening experiences as a counselor in a public high school are not so dramatic.

Opposites sat in my office talking past each other. Mom prim, on the edge of the seat, hair knotted tightly at the back of her head. "Her brother did not have a good experience here. But Mary's bright. She'll be fine."

Mary huddled, shoulders hunched, popping her knuckles loudly without attempting to speak for herself, letting her mother sketch the scenario. The knuckle-popping was aggravating the agitation in Mom's face. She caught Mary's eye and then glared at her hands, but kept talking. Mary hunched lower, but the knuckle-popping got louder.

I politely redirected the conversation. "Mary, how do you feel about this school?"

"It's so big," she said quietly without looking me in the

eye. "Do they have girls' gymnastics here?"

"Yes, we do. And no one has ever been permanently lost in the hallways. And, by the way, one of my sons can pop his knuckles louder than you."

A tiny smile teased the corners of her tense mouth. Her mother continued describing big brother's misfortunes in our public school. Mary seemed to float into another world.

Mary's mother wished Mary would talk to her, but Mary needed a sense of acceptance to feel free to reveal herself. She needed some sign that even knuckle-popping was okay before she could speak.

▼

Clint wouldn't dare pop his knuckles in his dad's presence. Though an athletic seventeen-year-old twice his dad's size, he sat mute as Dad rehearsed his shortcomings, his failing grades, his inconsistent homework, his avoidance of classes when he got behind. Dad thought Clint was unfeeling, that he cared for nothing and no one. As his father and I left the conference room, Clint stayed behind, out of sight until Dad had disappeared from the hallway.

Later, alone in my office, Clint blurted out, "He doesn't even know me! He just wants to keep my step-mom off his back." He let loose a flood of memories of his mom watching him play pee-wee football years before, wishes for his dad to treat him like a person, compassion for his mom's living conditions, confusion about how to get along with his step-mom. Clint was far from unfeeling. In fact, he was feeling so strongly that his emotions were sidetracking him from his school agenda.

One of the most frequent unspoken pleas sounded in my office is *Please hear me*. Adolescents can talk a mile a minute in the school cafeteria, then clam up in their parents' presence. Knuckle-popping may be their only way to speak out at the moment.

WHY TEENS DON'T FEEL HEARD
Today's teens have more material goods than previous generations. My four teenagers groan when I begin to recite

my deprivations contrasted with their wealth. My wardrobe decisions meant choosing between two corduroy skirts, both of which I had made on our treadle-foot Singer; they rummage through drawers of jeans and flannels and then search for just the right pair of shoes—which have to be just the right style and just the right color. For some reason my lessons from the past don't make them appreciative of their goods or sympathetic of poor Mom.

Adolescents today are a study in contradictions. They have financial power to use charge cards and are a lucrative marketing target. At the same time, they're in economic limbo, still students, not old enough to vote, unable to live independently, and at times difficult to live with. As a group they know little about geography and political affairs. But many of them can access networks to obtain an abortion or a prescription for birth control pills.

Teens certainly have more opportunities today. They appear to have more information available to them, more choices for education and training, more ways to earn extra income, and more possible diversions for entertainment. But they do not have more of everything.

They have fewer listeners. One of the most frequent laments I hear is, "Nobody listens to me. My parents haven't heard what I'm trying to say." Eventually the unspoken plea moves from *Please hear me* to *Please know me. Please know who I am as a different person—not like you, Dad. Not like you, Mom.* And definitely not like any other sibling!

It's no wonder that fewer and fewer teenagers are being heard at home. The family environment is less and less conducive to listening. Most women with children work outside the home. One in four adolescents under eighteen is growing up today without a father. These realities reduce the number of parenting hours and the amount of emotional energy available for children. Adolescents feel the impact keenly.

Our fragmented communities are increasingly unable to provide support or backup for nurture at home. For the most part, daily routines no longer include chats with the local mail

carrier, the grocer down the street, or the neighbor next door. There are fewer adults in the community available to listen to teenagers.

Many teens are suffering not only from lack of attention at home but outright aggression. Large numbers of our children live in warlike conditions. In one quarter of U.S. homes this past year, children witnessed a violent act. One in six lives with a chemically dependent parent; one in nine witnesses family (or neighborhood) violence; one in seven is sexually abused. In all (allowing for overlap), about 25 percent of American kids are living with chronic, sometimes extreme stress that they are unable to escape or change.

Your family may not be part of these tragic statistics, but these changes are inevitably having an impact on you in some way, however indirectly. It's essential that you be aware of this information in order to understand the world of adolescents in which your son or daughter is growing up. These changing family realities powerfully affect the behavior of every child walking out the door, satchel over her arm, backpack or athletic bag on his shoulder.

WHY LISTENING IS SO IMPORTANT
These frightening trends cause some of us to wring our hands in worry and others of us to make plans to change society. But worrying immobilizes us, and changes in our culture take a long time. We can make a significant difference in our teens' lives *right now*—in a simple, effective way. We can *listen* to them.

Whether your teen is gliding smoothly along the river of life or negotiating rough water, he or she needs you to listen to his words and her heart. I want to spend the rest of our time in this chapter on four key reasons why listening is so important.

Listening Lets Your Teens Know You Love Them
Early one morning I got up and noticed the answering machine light on our phone blinking insistently. In my robe and mostly asleep, I pushed the memory button. "Robby, I love you," a young sweet voice cooed in almost a whisper. "This is _____.

Call me when you get home."

The effect was stronger than a morning pot of coffee. Now fully awake, I considered my junior high son, whose world consisted of soccer, a new guitar, and wrestling with his brothers. Or so I thought.

Love is probably the most confusing emotion adolescents feel. No wonder. Watch prime time television. Open a teen magazine. Look at billboards. I need not elaborate. You are as aware as I am that our society equates love with sex and selfishness. So when adolescents crave intimacy, it's no surprise that they think sex will satisfy that craving.

Children have a big hollow space inside that can be filled only with unselfish, consistent love—interested in their welfare and accepting of who and where they are. When children become adolescents, the hollow space gets bigger.

We know some of the ways we can fill the hollow space for our children. We know that bandaging their injuries and providing a consistent place called home shows love. But other factors in those hollow spaces vary, and we can only fill them if we listen to find out what our kids need.

Most teens do not assume that their parents love them for who they are. Many live in fear of losing their parents' love. When we listen to them they hear, "I love you for who you are, not just for who I'd like you to be."

Remember when you spoke to your toddler while looking in another direction, trying to do two things at once? I'll never forget one of my children taking my face between both pudgy hands, turning my head and saying, "See me, Mommy, see me!" Your teenager will not be so overt, but eye contact is a vital way of showing love, and a vital part of listening. But in order to do so we often have to slow down—a challenge when we're talking while running different directions.

Your teen may turn your head by doing something he knows is slightly irritating—such as knuckle-popping. Or she may do something significantly embarrassing, even illegal. If she wants you to see her, she will discover a way to turn your head.

Hearing, however, involves more than looking. Eye contact is the easy part. A bigger challenge (at least speaking for myself) is to exercise emotional control and suppress your gut response while your adolescent finishes her statement, her plea, her philosophy; his plan for the evening, his opinion on that song. How does this kind of restraint show love? Waiting, allowing your adolescent to express his feelings, reveals your priorities. It shows that the person is more important than your differences. "Love does not demand its own way" (1 Corinthians 13:5, TLB).

One night after work I was busily making Christmas cookies. Tired feet, frazzled mind—but hey, it's tradition. Every family member selects a favorite recipe for this special time of year. This particular evening, one child sat at the kitchen table quizzing me on his homework. I offered half-hearted advice. He was becoming more confused and frustrated. Finally through tears he exploded, "Isn't my educational future more important than those dumb cookies?"

I put down the spoon and heard his words reverberating around the hollow space inside him. That space was changing, as was he. He cared more about this piece of schoolwork than cookies. "Lovin' from the oven" was inappropriate. My gut-level response wanted to say, "I'm doing this for you!" Instead, I quietly joined him at the table.

"For you." I hear students repeat what their parents are doing for them. But many times what they're doing "for their kid" is really what they're doing for themselves—to satisfy their own feelings about what parents are supposed to do. Even though as adults we know love is not shown with things, sometimes we still try to. But things cost us money, which we value less than our time—and kids know it. When we take time to listen, they feel loved.

Listening Lets Your Teens Know Where to Turn for Help
As dramatic as the lack of listening ears is the vast number of voices talking at teens. From individuals to industries, there's no lack of those who want to influence their decisions.

If your child is a high school junior or senior who has taken college board examinations, she will probably receive a few grocery bags full of mail from institutions of higher learning, each of which is "just right for her." Armed forces and technical institutes add to the stack. One institution offers to fly the student and his counselor free to the campus to consider them.

Your adolescent can join record clubs, video clubs, and the charge-card generation. Soft drink companies will give donations to schools to install their beverage machines. As the spender of many dollars annually, a teenager is an advertising target.

Decisions of how to spend money and what to do after high school are important, but only a small part of what teens must decide. They must also decide how to spend their time and with whom they will spend it.

Some teens are able to talk to other teens about significant aspects of their lives. But in my opinion, most of them share little more than superficial concerns with their peers. Most teens live rather lonely lives.

A significant "other" adult in a teen's life can make a world of difference. Even parents who enjoy their teens' respect and trust can seem unapproachable on some things. This condition is simply a given in some phases of life, which is why a significant other is important. Parents can influence who that other adult is. By nurturing a relationship with a special aunt or uncle, another Christian adult, perhaps a godparent, parents can provide indirect counsel when questions come up.

Kids take their big problems to the people who have listened to their little problems. I remind myself of this when kids want to talk about squabbles, an unfair grade, or what happened at rehearsal. Listening to a description of a movie or another person's hairstyle may seem irrelevant, but it shows them I'm willing to listen—period.

Perhaps you doubt your ability to give good advice. I understand, as a counselor and a parent. But in the overall picture of accountability, none of us can solve another's problems, nor should we. But we can listen, be a sounding board,

help in the comparison of pros and cons: "What would happen if . . . ?" We can also point people to others: "Maybe she can help you direct your efforts to find a job." "Perhaps you should see a doctor." "Let's call and get more information."

Kids are more likely to come to us for help if they feel we will listen until we grasp the picture. Though quite open to varied opinions, kids can become temporarily deaf when they detect a lecture coming or a session of laying down the law.

Occasionally I'll ask a student, "Why not ask your Mom or Dad about that?"

The responses often come back, "I'll never hear the end of it." "He'll use it against me later." "She'll tell the neighborhood." Sometimes we parents (I include myself) can be insensitive nags. Kids don't have all the answers. If we want them to come to us for help, we must accept their questions without putting them down.

Sometimes, reinforcement is all that's needed. They've made a decision, and now they need a dose of courage to help them live out their conviction.

A senior girl sat in my office fingering an empty chain around her neck. I had last seen it with her boyfriend's ring dangling there. As the door closed, she wept softly. "It's over." After six months, he had said it was either all or nothing. She chose nothing. Breaking up was more painful than she expected; the attachment was strong, and the senior prom was ahead. She couldn't tell all of her friends the whole story.

The help she needed was someone to praise her. I knew her parents would, but she wasn't ready to talk to them yet, and she needed reassurance now. Through one crisis, listeners can strengthen teens for future challenges. Even when teens know you will hear them, they sometimes have to choose the time when they're comfortable to talk.

Listening Can Mean Fewer Arguments
A frequent move in our house full of teenagers is the shadow box. A fist flies a micrometer from a nose. Two more fists go up. The shadow boxer smiles. The other may or may not.

What a visual picture of how arguments begin. One person attacks another person's opinions. Impulsively, the other assumes a defensive position, which usually means digging in his heels. An argument inevitably results.

What if, after the first fist flew, the other person stood unflinching, with a relaxed smile? Listening to our teens helps us smile quietly through their shadow boxing.

First let me say that a family who has no arguments is probably a family who exists together without caring or relating. When people of different personalities, different temperaments, different ages, and different interests live under one roof, some arguing is a fact of life.

But somewhere beyond healthy arguing is that state where conflict keeps people on edge, teens are afraid to say what they are doing or even thinking, and parents are relieved when the kids are out.

Why does increased arguing seem to accompany adolescence automatically? There are two very important reasons. First, each person is unique from birth, and adolescence is that time when the person must differentiate from Mom and Dad, from family, and from everyone else, for that matter. Some differences are more easily accommodated and allowed. Others set off shock waves. Individual differences affect who argues and why. At this stage, teens must let family know who they are.

The second reason for increased arguing is the nature of the world in which our teens live today. Perhaps more isolating in some ways than our world, it is also more crowded —-a difficult scene in which to carve out identity and independence. We said earlier that the hollow space inside a child grows in adolescence. Arguing is a way to demand attention, to see what others will do about that space. The environment often takes more out than it adds, so our teenagers come home hollow, needing to be filled.

Knowing more about their environment can help us be less defensive. Whether we feel things were better in our time is not relevant in this context. We have to carve out our relationship in the here and now. When we listen, we become better

acquainted; we find that kids are a bit more predictable. (Notice I said "a bit.")

One of the greatest compliments I have received from my daughter was her description of my husband and me. "They're not your basic, clueless parents," she explained to a new friend. We had been through a crisis together. We had learned more of the campus and sorority life, and a lot more about her. Yes, we argued. We also listened. We came to know her better. We share a new level of understanding and acceptance.

Important issues have come up since. We know her and her environment better. We have a little track record in listening. She knows that we're on her side. Family is more than a common last name.

Shadow boxing is not necessarily a request for an argument. It may be an attention-getter or a test to see whose side we're on. It's definitely an exercise in growing up. Listening helps us stand there smiling instead of digging in our heels.

Listening Can Lead to Healthy Discussion

What is the difference between an argument and a healthy discussion?

I think the answer lies in *who you're listening to*. When you're listening to the other person, it's a healthy discussion; when you're listening to yourself, it's an argument.

The skill of listening to another person instead of ourselves is not granted to us upon achieving the status of parenthood. If it seems too difficult, sometimes we stop having healthy discussions in order to avoid arguments, which deprives our children of an important benefit families can offer—the ability to think and express their thoughts in words.

Educators emphasize the development of critical thinking skills. One educational technique used to enhance thinking skills is waiting after posing a question, in order to give the student time to reconsider and evaluate. Parents can use this technique for healthy discussion. When a restriction must be imposed, ask your teen what she would suggest and give her time to get back to you with an answer. I find this difficult to

practice because I want speedy resolutions. But I have learned more about my children from hearing their proposed restrictions and why.

Critical thinking skills are enhanced by asking for supporting evidence. In Harper Lee's *To Kill A Mockingbird,* Atticus repeatedly drawls to Scout, "Do you really think so?" This simple question helps teens think about what they are saying, and possibly even change their viewpoint. As they reword their viewpoint, knowing we're listening, they expand and refine their thinking skills.

Do you remember when you first discovered that you knew something your parents didn't know? I remember Charles making a statement about permafrost at the dinner table. "What's that?" I asked. He immediately improved his scholarship in social studies and impressed me frequently at future meals with information on volcanoes, subcontinental climates, and ozone layers. To acknowledge that you're open to more information encourages teens in constructive critical thinking.

The same educational principle applies to critical thinking about our emotions as well as about information. "Do you really feel that way?" This question has led to healthy discussion between our adopted children and those born to us. They can't read each other's emotions, and neither can we. Much remains unknown unless we say it. Adolescents become more in touch with their feelings when they try to describe them.

In a good marriage, partners accept that they cannot read each other's minds, that they must say what they are experiencing. The same is true for a good relationship between teen and parent. Teen-parent communication often mirrors the communication in a marriage. One student was hiding information from his mother. She called me and discovered his grades and attendance. She was receiving presorted mail since Scott got home before she did.

Then Scott encountered another problem at school: I called his father. Dad was unaware of any previous problems. "She never tells me anything. We almost got a divorce over this." On he blustered. Teen-parent communication was consistent with

marital communication. One way to promote healthy discussion with your teens is to practice it in your marriage.

Reasons to listen? Listening lets your teens know you love them and where to turn for help. Listening can mean fewer arguments and lead to healthy discussion. Listening helps fill that large hollow space inside, and gives them information and courage for bouncing from the springboard of family into independence.

HOW TO FIND THE TIME

There's one more reason why listening is so important that encompasses all of the above. As a parent, you want to know your teen better. That person who confuses, sometimes exasperates, and usually challenges you is unique and wonderful. God made your child and then broke the mold. The teen years are a key stage in determining many future years of relationship. Many adolescents are on the brink of leaving home without ever really living under the same roof with you again. I write this from the only empty bedroom in our house; Valerie calls a dormitory home now.

Time for cementing a lifetime friendship runs by quickly. Take advantage of the fleeting opportunity called adolescence. *Carpe diem*, the ancient Latin phrase that literally means "seize the day," is relevant advice for parents of adolescents today.

As working moms, our challenge to find listening time requires determination and ingenuity. We can rise to this challenge by creatively using every available moment—whether it's taxi time, shopping trips, running errands together, sorting clothes, or cleaning up after meals. Some have discovered that a meal at a favorite restaurant, one on one, is good talking time. Walking or running together, going to a flea market or garage sale, or any place or activity where you can hear each other are all ideas for opening up the channels. If it means taking time out from other things, set your priorities according to the importance of listening to your teen.

Long drives seem to be conversation stimulants; maybe the captive audience factor loosens the tongue. I recall our caravan

embarking on vacation with Dad, supplies, and three boys in a van pulling the boat up front. My daughter and I followed in her truck with the bikes and more supplies. Since we're both gesturers, Bob could see our discussions in his rear-view mirror. Our erratic driving reflected our conversations—speed-ups, slowdowns, and occasionally neglecting to follow road signs and our caravan leader. Then I came to a complete halt at a "Stop Ahead" sign and eventually lost sight of frustrated Dad. I think our fearless leader got tired of pulling over and waiting for us to catch up. After Val took the wheel we actually sped by him, oblivious until the familiar horn disrupted our conversation.

Another area requiring creativity for finding time is listening to how our kids are doing in school. Working moms usually have little or no time for volunteer work. My days as room mother and picture lady ended when I entered the workforce.

But just because you can't often get to your teen's school doesn't mean you have to lose touch with her progress. Use the telephone, as many parents do, to keep in touch with the school. You might also consider keeping a written record of your teen's progress—a simple sheet of paper with columns listing class name, homework done, grade to date, and teacher's signature. Send it to school with your teen. When he brings it home completed, it can become his ticket to privileges, such as free time. This record sheet is a helpful tool for working moms to stay current on how their teens are doing in school.

Evening events at school offer another access route for staying in touch. You may be tired on the night of open house, but that visit to hear the two-minute presentation by each teacher can be invaluable.

Some teens need careful monitoring; others are fairly self-sufficient students and require less structure. But no matter what kind of student your teen is, school absorbs eight hours of her day. It merits your attention.

Another challenge for working moms of adolescents is monitoring non-school hours. Latchkey elementary school children may need frequent phone calls for companionship and direction. But latchkey adolescents present different challenges. One

single working mom bought an answering machine and left a new message every day for her teenage son to hear when he came into their empty apartment. The feeling of connection lifted the loneliness and reminded him that Mom cared.

It's also important to find the time to listen to your teen's peer relationships. Friendships become increasingly important in adolescence, and a place to hang out sets the stage for talking, teasing, fighting, eating, and listening to noises loosely classified as music. The ideal is, of course, for an adult to be present. We have found that impossible at times. But we can still monitor and set limits. Sometimes our home is not available to anyone but Neffs. Other times, with our permission, others can be there.

It's tremendously important that you meet and evaluate your child's friends, because some of them should only be allowed in your home when you're there. "Hanging out" and "looking about" are legitimate parent pastimes. Hanging out means staying within earshot to get a feel for what the other adolescents are like. Looking about means finding out their interests, family situations, and hobbies.

First-time visits should take place when an adult is home. After getting to know your kids' friends, you may select a few who can be in your home with your kids before you return from work. That's a privilege, and some friends may never get that nod of approval.

We've all heard tragic stories of what can happen when teens congregate at an unsupervised home. Late-evening television clips used to run in our area asking, "Do you know where your children are?" Maybe we should post a reminder at our work stations for late-afternoon review that asks, "Do you know who is in your home and with your kids?" Before you give the nod of approval to your teen's friends, hang out and look about.

Most teens are underparented rather than overparented. Don't hesitate to monitor, monitor, monitor. Adolescents eventually make their own choices, and ultimately they're accountable for their own decisions. But we can exert a strong influence

in their lives by being present with them in all the ways open to us — getting on the telephone, using notes, dropping in on them at school, hangouts, or home.

A recent study reported that eight out of ten adolescents either favor or do not oppose their mother's working. The study also revealed another encouraging fact: within the range of behavior reported on, from marijuana smoking to attitudes toward school and parents, there was almost no difference between those with working mothers and those whose mothers did not work. Seventy percent were happy that their mom worked.

Some were glad that she wasn't home worrying about what they were doing. Others felt their mother's work preserved the non-smothering aspect of their relationship. Many supported her working because they felt it was good for her. They were also perceptive of their fathers' attitudes toward working wives, feeling that when Dad respected Mom's ambitions the marriage was strengthened.[1]

▼

Working mother, take heart. Adolescents are adaptable and supportive even while they're complaining about eating leftovers and mumbling about picking up after themselves. It's just that they may not tell *you* they're glad you're working.

My friend Sandy flew home from a business meeting early one Saturday morning to commute to a distant suburb with her husband for their son's football game. And then he hardly acknowledged their presence! Sandy and Bill wisely took a low profile. You can be sure their son will recognize in later years that he was a priority to Mom and Dad in the midst of their full careers, even though that cold fall morning he could only dispatch a shy glance in their direction.

I have a priceless mental picture etched in my mind. Crowding and condensing my morning volume of papers and appointments, I escaped to surprise my son, Charles, and have lunch together. Turning down the street along his usual walking route, I drove past him as he was walking home for lunch alone. In my rear-view mirror, I caught my son's expression and body language when he first identified Mom's car — meaning

we'd have a fast-food lunch together. As I watched his sideways leap with heels together, ear-to-ear grin with elbows flapping, this working mom gained a priceless memory well worth the frenzy to steal that hour from work.

Wally's dripping cheeseburger and fries were not my treat for the day. Seeing Charles' explosion of delight filled my tank.

Carpe diem: seize the day.

You may be wondering, "How can I find time for their spiritual guidance? How do I include that when I can barely accomplish the survival tasks of parenting?"

My answer may surprise or alarm you, but here it is: *If we neglect the basic survival tasks of parenting, we might as well forget about any attempts at spiritual training.* If teens sense that Mom or Dad don't know them, don't hear them, or don't consider them important enough to monitor their school progress or even to know where they hang out, they'll turn a deaf ear to any kind of spiritual direction.

The beginning of spiritual training for a child or adolescent is the trust experience of Mom and Dad mutually securing the family hammock. Even if one parent must hold the hammock alone, the essential foundation of spiritual instruction is to keep that hammock as stable as possible.

My purpose in writing this book is to help and encourage working moms in this experience. For specific help, I recommend books such as David Wyrtzen's *Raising Worldly-wise But Innocent Kids* (Moody Press, 1990); Bruce Wilkerson's *Family Walk* devotional material (Zondervan: Walk Through the Bible) for all ages of children; and Ron Hutchcraft's *Wake-up Call* (Moody Press, 1990), an adult devotional which is also a good tool for teens.

But of first importance over specific techniques for spiritual training is the quality of basic care and nurture in the home. I fear there will be little receptivity if the hammock is not secure. If you are conscientiously trying to understand, love, and listen to your teens, you're already making important progress in their spiritual enrichment.

So what's my parting advice to you across the kitchen table for how to really love your teen?

Secure the hammock.
Carpe diem — seize the day.

MOM TO MOM ON SURVIVAL WITH TEENS

Keep It Simple

A priority issue for moms with teens (as with moms of young
children) is: *preserve your energy*. Telephones and microwaves in
good working order are a good start, but they're not enough
to survive on. To make it in the long-term you need to keep
household demands as simple as possible. How do you do it?
Think *simplify*. Then ask what has to be done for survival.

Simplify the kitchen — one big trip to the grocery store with
a long list and a helper takes less time than frequent stops.
Microwaved fresh vegetables require less preparation time than
multi-step casseroles. Which of the following pictures would
your teenager choose? (1) A simple, team-produced meal with
a pleasant mom; (2) an elaborate feast with a frazzled grouch.

Simplify your wardrobe, and theirs too. Stick to the two big
critera for today's clothing: "washable" and "no-iron." Make it
a prerequisite for any family members buying all-white shirts
that they learn how to spot-treat and bleach laundry (unless
you have time to do it). Otherwise, welcome them to purchase
colored shirts, patterned *on the front*.

Simplify room clean-up. The two best tips I can offer you
here are: (1) do it infrequently; and/or (2) close the door!

Cutting yourself some slack in this way is necessary in
order to meet the continuous demand on you for huge quan-
tities of emotional energy. There's probably a good, logical
reason for the disproportionate nature of this demand. I don't
know what it is. But all of us working moms with teenagers
know how it feels!

Don't Make Decisions Late at Night

Communication after eleven o'clock at night is like computing
on a full disk. Just as young working moms shouldn't be asked
to put one foot in front of the other after 11:00, neither should

working moms with teens be asked to make a thoughtful decision after that hour. We're likely to be brain-dead by that time, or some similar state.

Need an answer for questions thrown at you late at night? Try these easily memorized responses:

"No!"

"We'll discuss it in the morning."

"Even professional athletes are allowed to play in dirty uniforms."

Building on Your Investment in the Future

▼

In my work as an educator in a public school, I register incoming high-schoolers. After verifying residency, I complete a family information sheet. I ask the simple question, "Who is in your family?" Sometimes, as students are answering me, I grow confused sorting out sisters, brothers, half-sisters, half-brothers, and people in the "I'm not sure, but she lives with us" category.

I'm not the only one confused. During the same registration process in a nearby grade school, a young man was asked the even simpler question, "What's your name?" He gave three different answers—because, as he explained, each name had been given to him by a different mom, and he couldn't tell his teacher his real name because he wasn't sure which mom was his real mom.

The family is in a state of rapid change. As we saw in chapter three, the nuclear family—Dad working, Mom home tending the household with two children—is disappearing. This structure characterizes less than seven percent of the population in the United States today. Potential for a permanent marriage is about fifty-fifty.

Forty-two percent of white children today do not live with two parents, and 86 percent of black youngsters will spend most of their lives with one parent. For children born in the eighties, the proportions will increase to 70 percent for whites and 94 percent for blacks. The average white child spends one third of his childhood with one parent; the black child, two thirds.

Ten different family types are now common, and two parent-families are not the same. Fifty percent of marriages are remarriages, and 60 percent of those end in divorce. Within a few years from now, more people will live in second-marriage families than first-marriage families. It is simply no longer possible to speak of "the American family."

One of the major forces creating change today is the movement of women from home into the workforce. Some see this movement as a wrong turn off the prescribed route of God's plan for our lives. And so, the thinking goes, we need to "get back" to our traditional structures.

But the reality seems to be that there is no turning back to what used to be—even if we were all in agreement that it was desirable to do so. We need to look ahead. And we will find God there as well, at work to use the new struggles and challenges of our lives for His purposes. If He is the God of all ages and of the whole universe, His Word has truths for us today and for our children tomorrow.

This is one of the exciting challenges of being a woman in these times. We have greater opportunities than women have ever had, more options, more education, more choices, more channels for making our voices heard in society. God can glorify Himself in new ways through our lives and through our families.

God knew that in this moment of history, mothers would be in the marketplace. This phenomenon does not cramp His ability to meet family needs—instead, it offers us new opportunities to understand how His grace is sufficient for *all* our circumstances. Because He is with us in these changing times, change can be positive.

LOOKING AHEAD—
WHAT DIFFERENCE WILL WE MAKE?
Talking with working mothers, I sometimes feel as if we're galley slaves, confined to our rowing bench on a large swaying ship.

We're slaves to the bills of mortgages, car payments, and credit cards. It's difficult to get ahead of financial demands long enough to break free.

We're slaves to schedules—afraid to get behind, hopeless that we'll ever really catch up because we're already rowing as fast as we can.

We're slaves to calendars—not just daily and weekly, but for months and years ahead. One working mom has next summer's calendar organized for her three youngsters, ages two months to seven years. She must, she says, or they won't have a spot in appropriate camps and daycare.

We're slaves to our work. We read articles about Mommy tracks and professional excellence and we row faster and more furiously. Because we're Christians, we hold ourselves accountable to high performance; we want to be good stewards—a laudable objective.

We can get so consumed by the daily demands that we forget there's a world out there we're influencing in one way or another. Let's go up on deck and see where the ship is going. We need to look ahead in order to think about what directions our rowing is taking us in. If we could stand together with the next generation and look back at our progress, what would we see?

Would we see whole women and men, thriving as they live for Christ and use their abilities for God's glory? Would we see that we who called ourselves Christians made any difference—or even were any different ourselves?

I think God will be glorified as future generations see the diversity of women's work in our day. I think it will be observed that women in these days had more freedom to express His image because we had more opportunity to exercise this diversity in our homes, in the marketplace, and in both places.

The closed doors of many churches to women using some gifts and abilities has not limited God. Our movement into the workforce has opened up new arenas for using the abilities and energy God has given us to be salt and light in our world.

The accompanying challenge is that the salt retain its saltiness, that our light remain bright. As Christian working women we need to be as close as we can get to our Creator, our Enabler, our first love.

Will the next generation see our opportunities as privileges that we squandered, or gifts from God that we used to glorify Him? Will they see us turning our backs on the troubling changes of our time, or confronting them in our efforts to be Christlike and true to the principles of our faith? Will they see us hoarding material possessions to fill up the family barn, or sharing them with those in need?

Our children, of course, will be part of the next generation that is shaped by our influence—negative as well as positive. But our choices will also be felt through the social structures we have been part of, consciously or unconsciously. These institutions will have tremendous impact on our children.

Because we care so much for our children, let's talk about how we're impacting the institutions of our present and their future. Some will say I'm getting political. So be it. I recently heard Dr. James Dobson defending his involvement in government and any other sphere that he can influence. He stated that the family was under such attack through governmental policies, judicial influence, and education that he had to speak out regardless of criticism. So be it.

As a working mother, I see negative influences on my children—on all children. Yes, as an individual I read the Word of God, make decisions before Him, and pray. But perhaps there will be more hope for the next generation if I attempt to arrest the illness in some of our institutions. Only God can cure. But I am His servant—salt and light in this world's institutions. And I am a mother: through my children, I have an investment I am responsible to nurture. As future generations look back at families, the marketplace, our nation, and

the Church, I hope they will see that we have been building on our investment in the future.

INVESTMENT IN FAMILY

The jury is in on the effects of the changing family on children. Youngsters are getting less attention. Parents and relatives are spending less time with them. The kind of family a youngster lives in is in direct correlation to her behavior problems, and, to a lesser degree, her academic achievement.

The jury is still out on the effects of working mothers on children. Some studies suggest the effects are detrimental; others indicate there is no harm and even some benefit—as we've explored in earlier chapters. What amazes me, though, is how little attention has been given to the effects of non-parenting fathers—or perhaps I should say non-nurturing fathers—during the role-restrictive era, and the consequent detrimental effects on children and mothers when Mom bears sole responsibility for the children. In one study, kids were asked to rate the greater loss—never being able to watch television again, or never being able to speak with their fathers again. Three-quarters said they would miss TV more.

I hope future generations will see families in which Mom and Dad face each other holding the hammock that supports the children. As we saw earlier, this was not the case in the previous generation. Mom at home was often holding the hammock by herself. Father was still in the picture, so the family looked healthier, but it was not.

How can we help our society give hammock-holding back to dads? Step number one is to *help our society rediscover fatherhood*. This means we should encourage working mothers to stop trying to do it all. Much is written on how to be the all-efficient working wife and mother—how to do it all and have it all. We can't. We shouldn't. Children suffer and fatherhood recedes into the distance.

Step number two for balancing the family hammock is to *help our society rediscover paternity*. An increasing number of children do not know who their fathers are. Their mothers are

working and often doing the best they can. We working mothers know of their plight because we sometimes work side by side. We care about their children, too.

There has only been one virgin birth since Adam and Eve. Making a baby is a team production, as most first graders can tell you after health class. But our society—including some Christian circles—gives accountability and responsibility to Mom, not Dad.

A few years ago I sat in a circle of professionals, going through those get-acquainted activities common at seminars. One question we all had to answer was, "Tell us about your family." One man responded, "I have two children—to my knowledge." Everyone laughed—but me. Making babies is no joke.

If we care about families, paternity is a serious matter. Paternity can now be legally established through court-ordered testing methods, followed by child-support orders entitling the child to income and health insurance. Working men are more likely than working women to have access to health benefits. Paternity laws channel that help to men's offspring.

What difference does it make? Twelve million children lack health insurance, and one hundred thousand are members of families with overwhelming medical needs that exhaust their insurance coverage. Establishing paternity provides help for many needy children. Scripture commands this kind of accountability: "If anyone does not provide for his relatives, and especially for his immediate family, he has denied the faith and is worse than an unbeliever" (1 Timothy 5:8).

Paternity may not be an issue for your children, but it is for many. As I register new students, I increasingly see birth certificates with a blank space for the father's name. This increasing "fatherless" trend has tremendous implications for our generation of children. It creates circumstances that are neither biblical nor workable.

Moms in the marketplace can help network the information that there is help for establishing paternity and sharing parenting responsibilities. In my efforts, I've discovered that

working women *without* children are also concerned about paternity issues. Single women who are childless still share the financial burden through their taxes. But more importantly, they share our concern for deprived children.

When I consider the plight of "fatherless children" in our country, it strikes me as sad that legislation and the courts have had to address this issue. Why haven't our Christian communities, our churches, and our parachurch organizations been pressing on parentage issues? It's in part because of the silence of women, my silence included. I've been complacent, even unaware, of the burden of unbalanced family hammocks. But the reality is all around us: 30 percent of working mothers are single parents, of which the majority remain below the poverty level. Lay this woe at the feet of broken marriages and a society that does not hold men as accountable as women.

Children suffer in this reality. Three-fourths of them receive no support from the non-custodial parent. Other statistics indicate the resulting stress: Four percent of children age three to seventeen and living with both biological parents have seen a psychiatrist or psychologist for treatment of behavioral problems. For children living with a mother or father only, the figure almost triples, to 11 percent. It does triple for those in mother-stepfather families, at twelve percent. It hits 15 percent for those in father-stepmother units, and 16 percent for children living with neither biological parent.

Maybe churches could help support children by adopting the perspective that Jesus was teaching when He said to the superficially pious people of His day, "You have a fine way of setting aside the commands of God in order to observe your own traditions!" (Mark 7:9). He criticized them for giving money to the temple that should have gone to support their needy family members—in this case, parents.

What if churches preceded the offering collection with the announcement, "Before you contribute to the church, pay your child support. If you've made a baby, support that child. Don't give to God what should go to your child. Whether child sup-

port comes from a non-custodial man or woman, it must take priority!"

Working mothers can make a difference in what the next generation sees when they look back at our families by speaking out for the importance of fatherhood and paternity—and then backing up their speech with action.

INVESTMENT IN THE MARKETPLACE

I hope that future generations will see that we have been building on our investment in family through the marketplace. I hope that for them, men and women working and parenting in mutual cooperation will be a familiar scene.

In order for this to happen, the marketplace needs to become family-friendly. Those in the contingent workforce, which means the flexible marketplace, are better able to combine work and parenting. This should be considered a viable alternative not just for working mothers, but for either parent. Families will be strengthened by flex-time, shared positions, and either parent working at home.

Corporations have begun to catch on that what's good for working moms is good for business. The commercial real estate industry has begun to see the advantage of making provision for children in work sites. Many commercial developers are now following the accelerating trend to build childcare considerations into their facilities in order to attract tenants.

A major impetus behind this change is that daycare is in short supply. In 1988, a study by the United Way of Metropolitan Chicago found that childcare demands for three-to-five-year-olds in the city exceeded availability by 39,300 slots.

Some companies are even providing preschool and grammar schools at work sites. What do you suppose motivates these businesses to such pro-children action? The following paragraphs describe the connection:

> Women have become an essential part of the American work force. The nation could not thrive without their productivity, their brain power—and their taxes.

Millions of families depend on their earnings, often for basic necessities.

The nation also needs women to bear a new generation of children and to mother them with love, intelligence and personal attention. [My question again — Here's maternity; what about paternity? Where's Dad?] Women have a right to insist that it not be so difficult to balance these two essential, demanding roles.

The whole burden of social change occurring as millions of women move into the labor force should not fall on children and on the mother-child bond. It is far safer to insist that some of the adjusting and changing be done by business [I ask again — what about fathers?] and not by families — especially when such innovation is good business.[1]

The flexibility opened up by these changes in the marketplace is certainly a good benefit for working women today. But it will truly benefit the next generation if those options become available to working dads as well.

My soul winces at the thought that we care for our children because it's good business. But you don't bite the hand that feeds you. Let's build on these positive developments by sounding the call to recognize the importance of parenting in today's marketplace environments.

INVESTMENT IN OUR NATION
Christian lobbying groups are facing off against each other over support of legislation for childcare. The major sticking point seems to be whether such legislation will discriminate against families in which the mother chooses to stay home and care for her own kids.

Personally, I think this question will be irrelevant in the next generation. But the majority of our nation's children will suffer while we quibble over it. Let Mom at home have the same deduction because she chooses to care for her own children. Working moms don't want moms who choose to stay at home to be

treated unfairly. Let every working parent deduct every dime spent on childcare. If our nation cares about quality childcare, a 100-percent deduction would support that priority.

We should be voting for our government's help in caring for our children. (We can also ask the help of private foundations, or any other sources.) I wonder, *Will anything else in the federal budget matter if we don't care for our children?*

Many other countries, especially European ones, have long-standing policies on maternity leave and child-raising leave that are far ahead of the debate in this country. Some of them mandate full earnings and benefits for several months surrounding childbirth and allow either parent to take child-raising leave. The national consensus in these countries is that looking after families is an important investment that must be subsidized by all citizens.

In the United States, five states have enacted family leave legislation to date: Maine, Minnesota, Oregon, Rhode Island, and Wisconsin. It's encouraging that other states are proposing legislation. I see it as a national priority.

One philosopical barrier to national pro-family policies is that many people, Christians included, maintain that such policies only add unwanted government meddling in our personal, private, and religious issues. But we have laws related to moral conviction and ethical fairness. Shouldn't we also have laws that promote the health and well-being of families and children?

Working mothers have been able to vote since August 1920. (And they have been voting, despite former President Grover Cleveland's stated opinion in October 1905 that sensible, responsible women did not want to vote.) Our vote makes a difference in what the next generation sees. As Christian working moms, let's arrest the national illness of neglecting the needs of children. Let's line up at the polls and speak for our children through the ballot.

INVESTMENT IN THE CHURCH
When the next generation looks back on us, will they recognize what is labeled "the church" as a body of believers who love

God and actively imitate Jesus Christ?

I remember approaching beautiful cathedrals in Europe twenty years ago. I would first stand outside, feasting on the beauty of the friezes arching over the doorways. Anticipation mounting, I would study the grey, rounded windows that looked drab from the outside but whose crisscrossing shapes of lead promised beauty on the inside.

After tugging open the heavy doors, however, I would invariably feel let down by an eerie emptiness. There was nobody inside. When the light filtered through the stained glass, no one was there to revel in the beauty.

Will the church be faithful to speak out on the critical issues created by today's rapidly changing family? Or will its voice falter and grow silent under the challenge of taking a stand on what may appear to be risky ground?

I worship with a body of believers who have put changing tables in the men's restrooms as well as the women's restrooms. There is a parking area for single parents near the door. There is a ministry of auto repair and automobile provision for single parents in need. This church has a clear voice.

Churches can start with the needs and opportunities immediately in front of them. First, *provide anything and everything that will allow husband and wife to be together*. Typically, in most churches Mom is in the nursery or kitchen or Christian education wing. Dad is in the boardroom or at the building committee meeting. We're apart all week. Let's work at making church a together experience.

Second, churches can *plan time for small group sharing*. We need to hear how other Christian families are coping and succeeding. Yes, we want to be taught, to face the front and listen, but we need opportunity to face each other as well.

I become aware of how God is working in the lives and families of working mothers. I learn of God's intervention in the life of a runaway teen. I hear God praised for strength by a working grandmother who is also mothering and grandmothering in her own household. But I hear this at work, not church. Let's share our lives with each other on Sundays.

A third opportunity is the Sunday school program for children. Parents bear responsibility for bringing their children and helping with the work. But perhaps the church could bear responsibility for *helping us with the big issues facing families with children.* Former U.S. Surgeon General C. Everett Koop observed, "The church is involved in the total life of its people, but unfortunately, it has been virtually silent on sex education. One of the church's greatest failures is that the sexual behavior of our children is the same as the rest of society."[2] Yes, this is the responsibility of parents. But we need help.

When Dr. Koop publicized the problems of sexual behavior, many evangelicals did not like what they heard. "If you want to stop abortion, follow the public-health model of prevention and go to the cause of abortion," he recommended. "To do that we have to be willing to bite the bullet on the issue of contraception and press for greater public discourse and research funds to study methods of effective birth control."[3]

We have attempted to teach abstinence. It's God's law, His loving hedge for babies, girls, boys, teenagers, and mature men and women. On this we agree.

But we have failed to promote it effectively. With reverence and applause for godly people leading the crusades of "Just Say No" campus ministries, Sunday school teachers, and youth leaders, I pray that you have made a difference. But the stubborn reality exists that the sexual behavior of our Christian youth mirrors the world.

These realities bring the issue of birth control to the forefront. Teenage pregnancy is on the rise. Our children will reach the age when we cannot restrain them; they will make their own decisions and judgment errors. For the sake of the next generation—the world they will inhabit—we need to teach them how not to make babies until they are ready to parent them. We know that abortion is being used as a method of birth control. There are better choices for our daughters.

Unwanted pregnancies occur for many reasons. Statistics vary, but the realities of the whys of unwanted pregnancy, such as date rape and incest, are so grim that it's no wonder the

church would rather be silent on the issue.

Abortion and contraceptive education are hot, disputed, disagreed-upon topics. For the sake of our children and their generation, we must think and pray through the painful facts of our times in order for churches to minister to the real needs of families. These issues are not necessarily the key questions for working moms today, but they're extremely important. We care about the parenting choices of our daughters. And we are keenly aware of the personal and professional costs we pay for parenting.

I hope future generations looking back on the church today will see its attempts to teach relevant decision-making on matters of real life. We know the church cannot solve all problems. But as part of the church, let's help our Christian community move forward with the nuts-and-bolts crises in our lives. This subject merits our best cooperative efforts.

We can build on the excellent childcare programs that many churches are conducting in church facilities. If your church is establishing relevant short-term goals, suggest bringing support for childcare programs up to match the mission budget. Send a fact-finding committee to look at some of the child- and elder-care programs in churches. Some churches provide only space; others provide funds, staff, and oversight. Use the ideas of those who are doing it effectively.

Churches can encourage men and women through the challenges of parenting. Revelation 12 records the vision of a great dragon lying in wait to swallow a pregnant woman's child right after birth. Many people feel that fear today about bringing a child into the world. This is a perilous place for the innocent. For working moms it is complicated to say the least. Not only are they fearful of being able to juggle all their tasks, but the best environment they can provide is filled with unknowns.

I parent two children whose birth mothers saw their worlds as fearful environments for parenting babies. The woman in Revelation symbolized God's faithful people waiting for Jesus. God saved her offspring from the dragon and provided a place of protection for the woman. The church can offer that place of

protection today. We need a refuge, a place where we can be supported in our commitment to care for our children while trying to live like Jesus in a frightening world.

I hope that future generations see today's church challenging us to keep our first love. It doesn't take a tender heart to go through the motions of worship. We need to be confronted with the love of Christ, so that we will continually examine our motivation.

The pressures of the world tempt me to let this little light of mine grow dim, especially when I'm weary. Let's challenge and encourage each other in the body of believers to let our lights shine clear and bright as we cherish and care for our children.

A TIME TO SPEAK

It is commendable that within our Christian community during recent years, strong organizations with godly leaders have been formed to direct attention to the family. Dr. James Dobson draws much national attention to family needs with his Focus on the Family organization.

Interestingly, however, a renowned pediatrician who claims no Christian orientation, Dr. Berry Brazelton, is heralding the family cause. "Our culture is in grave danger because we're not paying enough attention to strengthening our families," he warns.[4] He says that parents are afraid to get down on the floor and play with their babies because they fear the pain of separation necessitated by work. Mothers don't want to breastfeed their babies because they can't continue when they return to work.

Dr. Brazelton warns that this distancing damages the parents' development as persons and cheats the babies. Children who don't make close attachments will have trouble with attachments throughout their lives. He sees a connection between the severe problems facing adolescents face today—depression, suicide, and drug abuse among them—as "obvious symptoms of lack of passionate families, of attached families."[5]

He does not suggest that moms are the cause, nor that

moms should retire from the workforce. He believes that work-
ing moms bring home a tremendous sense of confidence in
being successful at work: "They can hand it down to the chil-
dren. If they do it right, they can do very well by the children
giving them the same sense of importance and competence."[6]
We explored this advantage in the benefits we looked at in
chapter eight.

I'm grateful that Dr. Dobson and Dr. Brazelton are focusing
our attention on families. However, I believe that those of us
who are Christian working women and Christian working par-
ents need to become more vocal in expressing the needs of
family members—all family members of all types of families.
With all their insights, these competent, caring spokesmen do
not walk our daily paths. We working mothers must also speak
for families.

The solution, of course, is not to order Mom back to the
kitchen. Because traditional family life of thirty years ago seems
like a comfortable cocoon to some, they prescribe returning to
that perceived safety zone as a solution to current family ills.
But tradition isn't always right. God gave some women varied
gifts that can be utilized elsewhere. It will be difficult for lead-
ers to arrive at workable solutions unless those of us who are
Christian working women in the trenches speak out.

There are many reasons for our silence. Christendom has
not heralded the advent of women, and especially moms, in
the workforce. So perhaps we have entered more quietly than
our non-Christian, feminist counterparts. Some of those most
prominently carrying the banner for women in the workforce
have been opposed to Christian beliefs. We don't want to be
criticized in our churches, nor do we want to offend our sisters
who choose to stay at home. So we are quiet.

Another reason for our silence is that we don't have time.
Between finding jobs, creating careers, parenting, and meeting
household demands, we're not looking for causes to absorb our
"spare hours."

But the reasons to be silent aren't good enough con-
sidering the pressing problems we face. We need to share

our questions, experiences, and concerns as Christian working women. We must draw strength from each other around the kitchen table—strength that will empower us to go out into the world and make a difference.

I encourage you to build on your investment in the future of your children and of all our children—through commitment to the family in our society, through the marketplace, through our nation, and through the church as it seeks to minister to a troubled society so desperately in need of salt and light.

MOM TO MOM ON INVESTING IN THE FUTURE

Make Your Parenting a Priority
If you do little else in your lifetime, your role as a mother means you're making a precious investment in the future. Guard this investment by making your children your priority.

Then turn outward to other families, and work toward helping them guard their investment in the future as well. Parenting should be a priority for all of us, together.

Put Your Voice into Your Vote
Whenever you have opportunity, speak out for family and child-support issues with the power of your vote. As you can, communicate to your elected representatives how you feel. Let's unite our efforts to promote working conditions that recognize the importance of parenting.

Use Forums Already in Place
Some forums are already in place for working moms to make their voices heard—for example, political and community positions, church boards and committees, or parachurch organizations. Time demands on most working moms may preclude this kind of involvement, but even a few voices in strategic places can help turn the tide. For those few of you who may be able to take advantage of these public forums, *go for it in full voice.*

The Best You Can Do Is Good Enough

Please don't assume that I'm trying to turn all working mothers into social activists. Some of us will lead quieter lives than others, either because it's our personality type or because we're forced to select just a few priorities for focusing all our efforts.

If all you can do is to do your best one day at a time with the demands immediately in front of you, that's okay! In fact, that's great! Even if your voice is never heard in public discussion, your presence in the marketplace, and the priority you place on your family, will have an impact. Pray for God's grace in reflecting Him through all your challenges and struggles—He holds the future you're investing in.

Handling Change Without Creating Crisis

▼

What was the biggest transition in your life? I've asked this question on coffee breaks at work, at women's retreats, and at seminars. Here are some of the answers I've heard:

"My first job."

"When my child was born." (Usually the first baby, unless a later baby was handicapped or had special needs.)

"Getting married."

"Moving."

"Being single again—divorced."

"Getting fired."

"Becoming a widow."

"Pregnant again—with twins."

"Changing careers."

"When my youngest moved out."

Women's lives are full of transitions. It's estimated that women change careers five to seven times; men change careers four times. This does not represent the complete picture of transitions, however, because women's lives are more closely tied to the lives of their children as the primary caregivers. Therefore,

the changes and stages of children significantly impact women.

The birth of a child may not significantly affect Dad's work or career. Rarely does it *not* significantly affect Mom's work or career. Changes and stages of aging parents also create more transitions for women than for men. Births, deaths, moves, illness—all become part of the movement of life for working women. Transitions simply come with their territory.

Working mothers experience more transitions because they combine parenting and work. I think we're subject to greater stress in these transitions because we're so busy. We're juggling so many balls that when transitions come along, they can easily turn into crises.

Research documents this tendency. In a recent study of employees in a large public utility and a Fortune 500 high-technology company, the highest stress group was married women with children. The researchers said this was surprising. I'm not surprised. These women had fewer leisure hours than single parents and spent more time on home chores and childcare.

For working mothers, normal living is like the uphill portion of my morning run. I'm pumping as hard as I can. Adding a transition shifts the angle of incline so the hill is even steeper. An already hard climb just gets harder.

The future indicates that these transitions won't go away, and they won't get any easier. Our world is changing so fast we can't keep up with it. Every two-and-a-half years the amount of information in the world doubles. Libraries of thousands of volumes can be stored on computer chips the size of pinheads. By the time our kindergartners reach their senior year of high school, information will have increased sixteenfold.

Transitions are fueled by a divorce rate that continues at around fifty percent. Children's stages of change will be intensified by the changes in their environments. Increasing participation in the marketplace means increased transitions related to our work and career.

The difficulty of these transitions—whether having babies, coping with illness, or changing jobs—depends partly on how

our society, government, church, and families respond to our presence in the workforce and its relationship to family responsibilities. We can work for sound policies and practices that will reduce the stress related to our work and parenting, but progress is slow. We haven't been this way before.

As Christian working mothers, we need not allow circumstances to determine their influence on us, or the difficulty of transitions to become overwhelming. If we do, our lives will be in continual crisis as we struggle just to survive from one transition to another, looking desperately at the steep climb ahead. Instead, we can choose to depend on our faith to guide us on the uphill journey.

HANDLING THE FEAR OF THE UNKNOWN
One element that can turn a transition into a crisis is the fear of the unknown. A new baby, new surroundings, a new job, new expectations, new relationships—they can all be frightening because we don't know what lies ahead.

Transitions have increased my appreciation for Joshua, the humble leader of faith who set a strong example for how to handle change in the face of the unknown.

You may recall from Scripture's account that as Moses' successor, Joshua led the people of Israel out of the wilderness and into the promised land—a place he had previously visited only on a brief research mission. His job was to shepherd a skeptical, outspoken, non-conforming nation into this new land and create a permanent settlement. Crossing the Jordan River was only one transition of several for the children of Israel. It's one thing to go on a fact-finding tour; it's another to move in and establish roots.

The priests were to move the Ark of the Covenant toward the river first so the people could follow it, "since you have never been this way before" (Joshua 3:4). In other words, God was saying, "Don't forget your covenants. Keep them in view during the move."

When change comes, we need the same reminder. We're in a new city. In a new job. In a new relationship. As we get

ready to cross the river, we're to remember the covenants we've already made. Covenants provide the security of the familiar.

It's easy to focus only on the change and neglect our previous covenants. We can overlook our marriage in a career change. We can struggle to adjust to a new community and forget our quiet teenager. The Ark of the Covenant was a reminder of what God had promised and done in the past. Transitions are not navigated in a void. Yesterday is tomorrow's steppingstone. Our covenants of the past provide stability for the journey.

When God told Joshua to lead the people across the Jordan, the river was at flood stage—an inconvenient time for a move. Transitions happen when they happen, convenient or inconvenient. Our tendency is to want to control their timing, control our passage through them. But we can let go of that need if we remember that like the Ark of the Covenant guiding the Israelites' way through the unknown, God is ahead of us, leading the way through our transitions. He knows where we're going, and He knows the flood levels.

God instructed Joshua that the priests were to carry the Ark to the river and stand *in* it. I haven't seen the Jordan at flood stage, but the Eel River near my hometown in Southern Indiana is a hostile place during spring floods. Even the snakes who "s" their way across the Eel in its lazy August stage stay away from it in spring. God did not stop the raging of the Jordan until the priests got their feet wet.

The turbulence of transitions frequently looks hostile. Our first step of action, therefore, is necessarily a step of faith. This is the point at which we need to say to God, "I trust You to bring glory to Yourself through the turbulence. Hold on to me for each step, especially this first one, when I must enter the flood before I see Your protection at work."

Once the priests stepped into the currents, God did His work. But it was beyond their sight:

Now the Jordan is at flood stage all during the harvest. Yet as soon as the priests who carried the ark reached the Jordan and their feet touched the water's edge, the water

from upstream stopped flowing. It piled up in a heap a great distance away, at a town called Adam in the vicinity of Zarethan, while the water flowing down to the Sea of the Arabah (the Salt Sea) was completely cut off. So the people crossed over opposite Jericho. (Joshua 3:15-16)

The town of Adam was sixteen miles away; the people couldn't see the miracle. *So each step had to be a step of faith.* Aren't many of our transitions navigated like that? We've never been this way before. Each step may be according to our best judgment, initiated by the first step of faith. But often we don't see the miracle; we don't know when the flood waters will rise again.

God instructed the Israelites to take twelve stones from the middle of the Jordan and carry them to their new camp. He knew that His people were prone to forget what He'd done in the past. I'm encouraged when I review the notes I've written to God in the past. Sometimes I've pled, sometimes I've praised. Remembering how He's worked gives me new strength for the uphill climb.

We don't have to let the fear of the unknown create crisis out of change. Some changes we choose; others are chosen for us. We may decide to change jobs, but we don't control when our teenager sets out on a sudden and traumatic search for independence. We may elect to make a move, but we may have little control over factors of timing and location. Career shifts for either spouse may force a transition we wouldn't have chosen. But whether the change is of our choosing or not, we can handle it in positive ways.

TESTING OUR LIFELINES
Transitions provide an opportunity to test our lifelines. They're part of God's plan for our lives. God doesn't change what is important to Him just because we enter a transition.

The same questions we ask for God's direction in general (see chapter five) apply to transitions. I find that comforting. When everything seems to be changing, God is the same.

To the extent that we are able to make choices about our direction during transitions, we should evaluate our decisions against these criteria for making wise choices: (1) Is it in harmony with the Word of God? (2) Does it fulfill the law of love? (3) Does it fit God's calling for me?

These questions lead us to bring our work before the Lord once again, seeking the assurance that it is God-ordained, that we will be using rather than hiding the gifts He has given us, and that our motivation is based on faithfulness to our first love.[1]

One of the important comforts in answering these questions with and before the Lord is the removal of false guilt. Transitions require extra energy, extra strength, and focused thinking; we can't afford the distraction of false guilt.

We can also place our decisions next to the guidelines for seeking God's will in making life choices: (1) Does it benefit me personally? (2) Is it beneficial to others? (3) Is it a worthwhile investment of my resources?

People are resilient and can accommodate some change. Don't assume that a transition for you will be negative for your children or your marriage. Some stress is a natural and healthy condition of being alive. Change is part of being a growing Christian. What we must monitor and evaluate is "How much?"

Spouses can be our greatest support and encouragement through job changes, family additions, and parenting challenges. Most partners are tolerant of periods in which we can do little else but focus on survival. But marriage is a covenant that, if neglected beyond boundaries, loses its essence—intimate commitment to another person.

Children also survive some times when parents are less available. They rise to the occasion and are capable of considerable responsibility—for a while. Somewhere between rising to the occasion and accepting extra responsibility is the loss of childhood. Continual transitions can feel like a bombardment of crises to a child. This is when the freedoms of childhood are lost—a condition none of us wants for our children.

Reviewing guidelines during times of transition helps identify when we're creating crises in how we're handling change. As we evaluate our decisions in light of seeking God's will for our lives, we become better able to stay on course, hold tightly to our lifelines, and receive fresh understanding for how to live as Christians in each new circumstance.

Mothers entering the marketplace are in danger of straying off-course. I think we will survive, but our children may be at risk if we don't continually check our decisions against our Christian convictions. Our lifelines must be reliable for their sake.

A compass helps a traveler find direction only if its needle points true north. The story is told of a ship's captain who was attempting to clean the glass on his compass. When he pried it open with his knife, a tiny point of his blade broke off—just enough to deflect the needle ever so slightly. The deflection was just enough to swing the ship's course over rocks, and the vessel and crew were lost.

We must keep laying our choices before the Lord, digging into His Word for guidelines. Much is at stake.

FLEX TO THE MAX
Transitions teach us flexibility. Willing students learn; unwilling students burn.

Each transition creates someting new in us. The "new" can be skills, patience, sympathy, strength, tolerance, wisdom, and understanding. Or the "new" can be bitterness, resignation, jealousy, and competition. The question is not *whether* transitions change us, but *what* the change will be.

My husband and I are experiencing role changes not because we have philosophically studied them and determined to change, but because we are two Christians, hoping to lighten or share the other's load in the big and little challenges of our lives.

If a vehicle repair resource is near my work, I facilitate and monitor the repairs. Bob sometimes has flexibility to work at home when a child is sick or appointments have to be met with professional services. (It still seems to me that most "services" are

unaware of the advent of women in the marketplace.) There's little or no room for rigid roles in the dual career marriage, especially with children. Just because both parents have lofty career demands and goals doesn't mean the baby will not throw up with equal vigor on the suit of either one.

When Bob entered the elevator one day to go to his downtown office, he shed his topcoat to reveal a suit jacket with the telltale smudge of white formula on the shoulder at burp level and a wet spot at the waist. His colleague reported to me that he slipped off his suit jacket and worked in his shirt sleeves that day.

A godly characteristic grows out of necessary flexibility: the spirit of being willing to do whatever job has to be done. I see this in godly men and women in Scripture to a greater extent than I see it in our society—sometimes, unfortunately, including the Christian community.

Scripture provides many snapshots of people who were flexible during times of transition and challenge. After Saul was anointed king of Israel, he went back and plowed the fields while waiting for his new orders. Martha continued to serve people in her home after the public miracle of her brother's resurrection. The Lord Jesus washed the feet of his disciples. Paul, the great philosopher, apostle, and teacher, continued to stitch tents. Deborah returned to judging cases under the palm tree after the victory of war.[2]

Flexibility is especially important for keeping our marriages strong during transitions. Paul's guidelines for Gentile and Jewish believers in Rome apply here as well: "May the God who gives endurance and encouragement give you a spirit of unity among yourselves as you follow Christ Jesus, so that with one heart and mouth you may glorify the God and Father of our Lord Jesus Christ" (Romans 15:5-6).

I recently observed a Christian couple face the turmoil of their son's involvement with drugs. After costly rehabilitation, the problem reoccurred. They grieved for their son, felt humiliation before others, and questioned as they struggled uphill. Though they sometimes disagreed when considering "why"

and "what next" and "what should we do," they stayed together through great upheaval and change. Roles became insignificant as they clung to each other and preserved their marriage.

When they were tempted to come unglued, one said to me, "Our son puts down everything about our faith. What if he could add divorce to the failures he sees in us?" I believe someday their unity will speak to their son. Their mutual commitment during this hard time glorifies God.

Transitions force us to flex. In our family they have forced us to weed out the unnecessary. We evaluated whether organizations we belonged to were worth the time. We looked at what was truly important in standards of housekeeping, meals, shopping, even grooming and wardrobes. And after the transitions from our beginnings as two married students through the development of two careers in twenty-seven years of marriage with four children all going through individual stages of adjustment, plus continuing education and changing positions, we are still learning flexibility.

I sometimes wonder, If God were to issue the commandments in our day, would He add an eleventh? "Thou shalt hang loose; do not clutter your life with the straightjacket of the unnecessary."

We have many opportunities to step into the flood waters, to take our faith into new arenas, to see God at work in our lives in new ways. Count your blessings as transitions force you to shed old habits and expectations for the newness of change.

COMMUNICATE, COMMUNICATE, COMMUNICATE

Have you ever noticed that one of our responses to change is to clam up and hibernate?

Let's say I'm under great pressure due to a job change. Someone asks me how things are going. "Oh, fine," I toss off. "And how are you?"

The power of silence works against us during transitions. Many times others have gone through similar circumstances, or at least had similar feelings. If they can't provide guidance, they can often empathize—sometimes a help just in itself. But

they can't do anything if they don't know what we're going through.

Change will pressure you to ask for help. Don't fight it—transitions won't seem quite so steep when you're in communication with others who understand. If you hole up and keep to yourself, your struggle may well reach crisis proportions.

The marketplace is a valuable resource of support through communication. Many working women use marketplace networks to support each other by sharing experiences and resources.

Competition can interfere with this supportive communication, but it doesn't have to. When we see our work as God-ordained, using our talents and energy becomes an arena for cooperation, not competition.

We've been told that men are better prepared for the rigors of the marketplace by their childhood experiences in competitive sports. Maybe we didn't lose out. A competitive spirit shuts down communication. It requires keeping secrets to get ahead. This pattern can turn transitions into crises. You can't grasp a helping hand if you can't tell anyone you need help.

The same is true in marriage. There's been a lot written about competition in dual-career marriages and the effect on the male ego. But our Christian faith calls us to strive for faithfulness as mutual servants of the Lord, not as success-driven individuals out to prove their worth to the world and each other. With this perspective, the Christian dual-career couple can experience great freedom and great communication.

I remember one of those surprises in our marriage that drew me closer to Bob. My competent, usually smiling husband rarely reveals his fears in his work. In one of those bare moments, he told me of a fear he was facing. And indeed it was one of those cliff-edge issues. I have never faced that issue in my career, but I have known fear. And so I could comfort him.

Communication allows us to reveal ourselves honestly, so we can reassure each other and stand together. Sometimes we speak the truth in love. We advise or even confront. Sometimes we console, challenge, or comfort. Many times a transition

opens us up to needed personal change, especially as our ideas collide with those who are close to us and know us well. As iron sharpens iron, so one person sharpens another, the Bible tells us (Proverbs 27:17). And we're both better for it.

Proverbs tells us that we're tested by how we receive praise as well as criticism.[3] Communicating exposes us to both, which perhaps is why it's hard to open up and talk about the challenges of our transitions. But the risks are worth the gain: growth instead of stagnation through change.

STRENGTHEN FAMILY BONDS
On the surface, it seems that transitions would naturally pull families apart. But God works in mysterious, surprising ways. As I've talked with women about their transitions, they repeatedly said that their families were stronger as a result—not necessarily at the time, or in an apparent way—but sometime, somehow.

Here are some of the practical tips I've distilled from these conversations for strengthening family bonds instead of creating crises during transitions:

When you have a job change, try to keep childcare consistent so that your child isn't adjusting at the same time you are. This may require transportation gymnastics and logistical flexibility in your marriage.

Get to know the key caregiver of your child well. The younger your child, the more that person will be like a parent to your baby. Keep that person informed of challenges and changes so you can reinforce each other's efforts to maintain stability.

Keep a comprehensive family calendar. Every woman stressed this habit. It's especially important during transitions, when brain overload causes forgetting and confusion.

Our friends used their computer to create and maintain their calendar, which included directions to appointments and teen activities, not just time and which family member was involved.

The family calendar is a good idea for any family, but especially those with working moms or those experiencing major

transition. Then it's not just a helpful organizational tool, but a survival necessity.

Get in touch with family members early in the weekend. This practice is especially important when anyone in the family is experiencing change or added stress. One person's problems will affect the whole family — sooner or later. It's better to anticipate and prepare than to get caught off-guard.

Families have different ways of connecting this way. One family with young children frequently goes out for Saturday breakfast. Their weekdays are busy and structured. The restaurant setting relieves them of the distraction of long grass, piles of laundry, and the ringing telephone.

Another family with teens has pizza at home, early on Friday evening. Since activities take them different directions later on, they start early with a sit-on-the-floor talk about what you want to do with the weekend or what was important about the week. Granted, the time is short, and they don't always sit down all at once. But the attempt works most of the time.

Watch general health, including your own. Most women said they were more likely to monitor their children's health needs, including sleep, than their own. One mother said, "When you're stressed with extra demands, if you don't take care of yourself, things will get worse before they get better!"

Spend some time with the Lord each day, even if it's a nanosecond. Reading two verses is better than none. Thank goodness for tapes, headphones, and commuting time.

Your family's habits of worship and learning may be affected by the transition. Talk about it. Pray together for help and wisdom. Tell them what you are learning in your experience with your Creator. The older your children, the more their spiritual growth is beyond your guidance. What you share may be brief; what you model must be real.

NURTURE YOUR OWN SPIRITUAL GROWTH
Of all the advice we working mothers need, this is the most important: *Remember your first love.*

Transitions sometimes prompt me, as they've probably

prompted you, to ask where God is in all this. The questions come round again: "Does He have anything to say to *this* situation?" "Does my being a Christian make any difference in this decision I have to make?" "Here I go picking up my Bible again—does it have any relevance for my uphill struggle today?"

Yes, and yes, and yes.

I am a mother, a wife, an employee. But first I am a Christian. The second chapter of Revelation reminds me not to neglect my first love. My people covenants can shiver or quake during change. If I face transitions armed only with a love for people, I'll run hot and cold depending on how circumstances fluctuate. But my first love, for God, is what gives me the consistent energy I need to keep going uphill—even when the hill gets steeper.

Hezekiah, king of ancient Judah, became my teacher recently.[4] He started out as a faithful servant of the Lord, leading his people in obedience to God's commands and in receptivity to the prophet Isaiah's guidance. Hezekiah was favorably compared with the great King David.

But then a crisis occurred in Hezekiah's life. While he was still a young man, he suffered a severe illness and was told to prepare to die. In bitter tears, Hezekiah appealed to the Lord to heal him, and the Lord granted him fifteen more years.

Had Hezekiah continued to remember his first love, these extra years could have become a season of even deeper devotion to God, and a continued strengthening of the nation under his leadership. But Hezekiah grew proud, and he turned his back on the Lord's kindness. When Isaiah prophesied the fall of Judah into exile in Babylon, Hezekiah said in so many words, "That's fine—it's not going to happen in *my* lifetime."

We often respond to the threat of trouble by wishing it away—away to some indefinite future that doesn't include us. It's tempting to make decisions according to what is easiest in the short-term, without having to consider the long-term effects. But remembering our first love means facing threats from the unknown in the confidence that God is with us, no

matter what happens. This is the source of our courage for growth through transition.

LEAN ON THE STRENGTHS OF OTHERS

As a new Christian, I remember searching for a passage that said, "God helps those who help themselves." I never found it. But I read account after account where God helped those who couldn't help themselves. And he often worked through other human beings to bring this help.

Changes in our lives often leave us at the end of our wits and the end of our strength. With mental freshness gone, we're out of ideas even for survival issues.

Sounds hopeless, doesn't it? But it's precisely the point where transitions bestow on us one of life's greatest treasures—the strength of other people.

When we moved last year, I was at work on the appointed day. My seventy-year-old mother-in-law packed up the entire kitchen at our old house. Then she unpacked, laid shelf paper, organized, and set up the kitchen in working order at the new house! This was a kitchen-for-six project, an accumulation of seventeen years in the old kitchen—a formidable task for anyone. I knew she had the organizational ability; she is a master at that. But her strength, willingness, and persistence was a blessing to me beyond measure.

Sometimes in our transitions we can lean on other relatives to help us. Sometimes they're in their own transitions and we must look elsewhere. It may be a neighbor. Or the church—although since we have little time to spend there, the ties may not be as strong. Our coworkers are more likely to be available simply because they're with us day to day, know our needs, and know when we're near crisis.

It's been said that the secret to the successful corporate businessman is a good wife. Many of us working moms need either a "good wife" or a nap. Of course neither comes with the territory, but transitional pressures often introduce us to new people. We have even more opportunity to make the wonderful discovery that people are there just when we need them.

Change has much to teach us about our strengths, but it also teaches us about our weaknesses and limitations. Here is where we can learn the precious lesson that we need each other.

▼

Parenting—the best of times, the worst of times. Our children have been called the generation at risk. I agree. In two decades, we'll see whether the best or the worst prevailed.

Parenting—the spring of hope, the winter of despair. Perhaps in our times of transition, we working mothers feel the winter of despair.

If our hope for families implies returning to some previous model, we *will* enter the winter of despair. Families have changed irreversibly. Mom in the workplace changes the meaning of "motherhood," "nurturing," and "family." To make a blanket condemnation of these changes and to blame mom's working as the cause of family dysfunction will keep us out in the cold.

I see possibilities for a warming trend because women and men have the potential for coming together again. Sharing the marketplace has necessitated shared parenting. Some fathers are connecting. Women are diversifying in how they express their gifts and make contributions to their worlds. Children will have new opportunities to grow in strong, balanced hammocks held between two parents who stand facing each other.

But the true cause for hope lies not in the indications observable in today's families, but in the miracle of God's grace at work to renew us for living in His image. Transition times can be the spring of hope because we are Christians.

"Forget the former things," the Lord tells us; "do not dwell on the past. See, I am doing a new thing! Now it springs up; do you not perceive it? I am making a way in the desert and streams in the wasteland" (Isaiah 43:18-19).

A new thing? My imagination races ahead to see families in the future summer that will follow this spring of hope. Different, yes. I see children assuming some responsibilities earlier than they did when Mom was home, adolescents becoming more accountable and dependable—desirable characteristics to

some degree. Kids will see moms doing different things. They will experience parenting from both Mom and Dad.

But kids will not need to become adults too soon, because of the increased parenting support of dads and greater responsiveness to family needs from communities and government. The marketplace will be more sensitive to families because women have heightened its awareness of the real treasures of the future.

A new thing. Though we may not see clearly what transition will bring, we do know that spring carries new potential. The iris bulbs that Grandma pushed into the chilling fall earth were gloriously changed by the transforming power of spring. The summer bursts of lavender blossoms bore little resemblance to the brown lumps from which they had sprung.

Our steps toward combining work and parenting may be wavering and slow, but we are not taking them in a vacuum. We bear God's image, we desire to use His gifts in us, and we want His best for our children. Because God is doing a new thing, this is the spring of hope.

MOM TO MOM ON HANDLING CHANGE

Deciding What's Important
Jobs last for a season of time, families for a lifetime, our relationship with God for all of time. When change seems to be throwing everything open to question, use this thought to help you set priorities for your activities, your goals, and your relationships.

Looking for Help
Have you ever wondered if anyone *really* understands what you're going through? Transitions often feel that way. Change is disorienting. We begin to long for someone who has lived our experience and can show us the way through it.

I don't need statistics to tell me that our world is in the midst of change. There's evidence enough in my own challenges as an employee, parent of four, wife, student, and

(I hope) growing Christian. As I face changes, choices, dilemmas, I search for role models. Has anyone else walked this road before?

I'm beginning to believe that looking for role models is not the answer. It's better to look to those who have navigated change of any kind with strong faith, rather than those who have successfully done what I want to do.

When you feel alone in the struggle, seek out someone who has learned more about God in the midst of change. You'll find that the old truths still hold true for a new day.

Notes

Chapter Two: Guilt: Dealing with the "G" Word
1. Kari Torjesen Malcolm, *Women at the Crossroads* (Downers Grove, IL: InterVarsity, 1982).
2. Miriam Adeney, *A Time for Risking* (Portland: Multnomah, 1987).

Chapter Five: Pursuing God's Plan for You
1. "Covenant," in W. E. Vine, *Vine's Expository Dictionary of New Testament Words* (McLean, VA: Macdonald Publishing Company, n.d.), pages 252-253.

Chapter Six: Getting Together: Moms at Home, Moms in the Marketplace
1. "Burden," in W. E. Vine, *Vine's Expository Dictionary of New Testament Words* (McLean, VA: MacDonald Publishing Company, n.d.), page 159.

Chapter Eight: Choosing the Right Care for Your Kids
1. See Stella Chess, M.D., and Alexander Thomas, M.D., *Know Your Child: An Authoritative Guide for Today's Parents* (New York: Basic Books, 1987).

2. Chess and Alexander, page 32.
3. Chess and Alexander, pages 37-38.
4. Marilyn Gardner, "America's Lack of Quality Day Care Cries Out for a Solution," *Daily Herald* (Chicago), 9 February 1990, Section 2, page 1.
5. Patrick Reardon, "Poor Child Care Tied to Low Wages," *Chicago Tribune*, 18 October 1989, page 4.

Chapter Nine: How to Really Love Your Teenager
1. Jane Norman and Myron Harris, *The Private Life of the American Teenager* (New York: Rawson, Wade Publishers, 1981), pages 39-41.

Chapter Ten: Building on Your Investment in the Future
1. Joan Beck, "Best-Run Firms Set the Trend in Help to Working Mothers," *Chicago Tribune*, 25 September 1989, Section 1, page 11.
2. Quoted in Ken Sidey, "Koop Calls on Church to Address AIDS," *Christianity Today*, 19 March 1990, page 43.
3. In Sidey, page 43.
4. Quoted in Eileen Ogintz, "Pediatric Politico," *Chicago Tribune*, 21 October 1988, Section 5, page 2.
5. In Ogintz, page 2.
6. In Ogintz, page 2.

Chapter Eleven: Handling Change without Creating Crisis
1. See Ecclesiastes 2:24 and 3:13, Matthew 25:14-30, and 1 Corinthians 4:4.
2. See 1 Samuel 11:5; John 11:1-12:2, 13:1-17; Acts 18:1-3; and Judges 4-5.
3. Proverbs 27:21 and 15:31.
4. For Hezekiah's story, see 2 Kings 18-20 and 2 Chronicles 29-32.

Author

Miriam Neff is a counselor in a public high school. She earned her master's degree in counseling from Northwestern University, Evanston, Illinois. For Miriam, working with adolescents is a fascinating challenge. Writing, her avocation, has focused on women's issues.

Miriam and her husband, Bob, and their four children live in Kildeer, Illinois. Two of their children are adopted. *Working Moms: From Survival to Satisfaction,* her fourth book, is the product of her compassionate concern for children and adolescents, acquired in her own daily experience at home as well as at work.

Miriam runs for recreation and peace of mind; her favorite diversions are water-skiing and reading.